10 STEP DRAWING

Horses & Ponies

Published in 2023 by Search Press Ltd.
Wellwood, North Farm Road
Tunbridge Wells
Kent TN2 3DR

This book is produced by
The Bright Press, an imprint of the Quarto Group,
The Old Brewery, 6 Blundell Street,
London N7 9BH, United Kingdom.
T (0)20 7700 6700
www.QuartoKnows.com

ISBN: 978-1-80092-118-4

Publisher: James Evans
Editorial Director: Isheeta Mustafi
Art Director: James Lawrence
Managing Editor: Jacqui Sayers
Development Editor: Abbie Sharman
Project Editor: Polly Goodman
Design: JC Lanaway

Printed and bound in China

10 STEP DRAWING

Horses & Ponies

DRAW OVER (50) HORSES AND PONIES IN 10 EASY STEPS

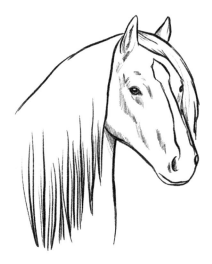

JUSTINE LECOUFFE

Search Press

Contents

≫ Heads & Features

≫ Horse & Pony Bodies

≫ From North & South America

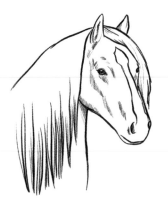

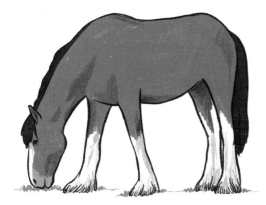
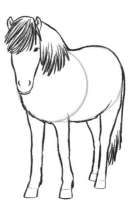

>>> From Europe

>>> From Africa, Asia & Australia

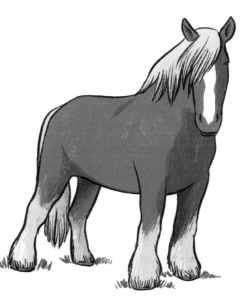

Introduction

In this book, you will find more than 50 illustrations of horses and ponies in a variety of profiles and poses, all created in just ten simple steps. So, whether it's a handsome, rearing Hanoverian, a beautiful, galloping Andalusian or a rugged, grazing Fell pony, it's time to choose your favourite horse or pony and get drawing!

TACKLING DIFFERENT SHAPES

There are more than 350 different breeds of horses and ponies, and they come in different shapes and sizes. The step-by-step instructions in this book show you how to use simple shapes or outlines as guides for placing heads, limbs and tails. This will enable you to get the proportions right.

At the beginning of the book, you will find a guide for drawing basic head and body profiles. Once you've mastered the basics, you can move on to applying these techniques to more than 50 different horse and pony breeds. Follow the instructions and guides for the shapes of the heads, bodies, legs, manes and tails to help you achieve a realistic appearance for different breeds, as well as a variety of paces, from walking and trotting, to galloping and rearing.

I have provided a colour palette at the end of each finished drawing. Use this as a guide, but feel free to use your favourite coat colours instead.

I hope you will enjoy creating the images in this book as much as I did. Drawing horses and ponies has never been easier!

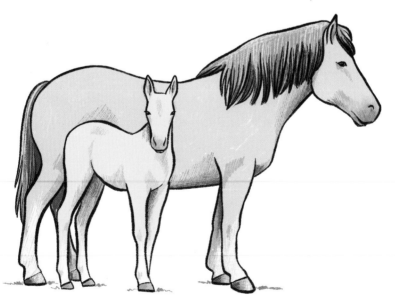

How to use this book

BASIC EQUIPMENT

Paper: Any paper will do, but sketch paper will give you the best results.

Pencil, eraser and pencil sharpener: Try different pencil grades and invest in a good-quality eraser and sharpener.

Coloured pencils: A good set of coloured pencils, with about 24 shades, is really all you need.

Small ruler: This is optional, but you may find it useful for drawing guidelines.

FOLLOWING THE STEPS

Use a pencil to draw the shape guidelines in each step. Use a dark-coloured pencil to add the outlines and details. Then erase the underlying pencil. Finally, apply colour as you like.

COLOURING

You have several options when it comes to colouring your drawings – why not explore them all?

Pencils: This is the simplest option, and the one I have chosen for finishing the pictures in this book.

Stay inside the lines and keep your pencils sharp so you have control in the smaller areas.

To achieve a lighter or darker shade, try layering the colour or pressing harder with your pencil.

Horse and pony coats come in different patterns and colours, and the manes and tails have a different texture, so once you're confident with where the shading should be on each one, try varying the tones you use.

Paint and brush: Watercolour is probably easiest to work with for beginners, although using acrylic or oil means that you can paint over any mistakes. You'll need two or three brushes of different sizes, with at least one very fine brush.

Top Tip

The shape guidelines in each step are shown in blue. These should be erased once the dark outlines are completed and before colour is applied.

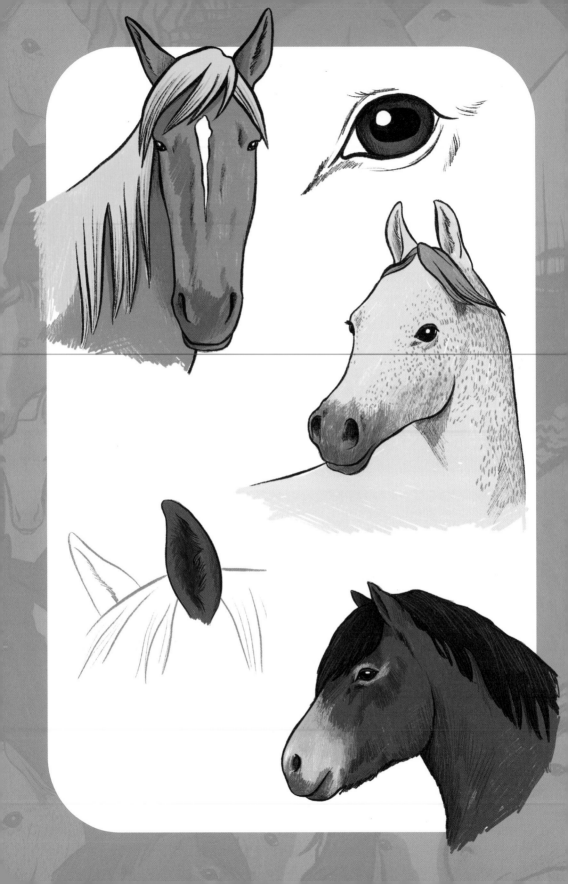

Heads & Features

Eyes

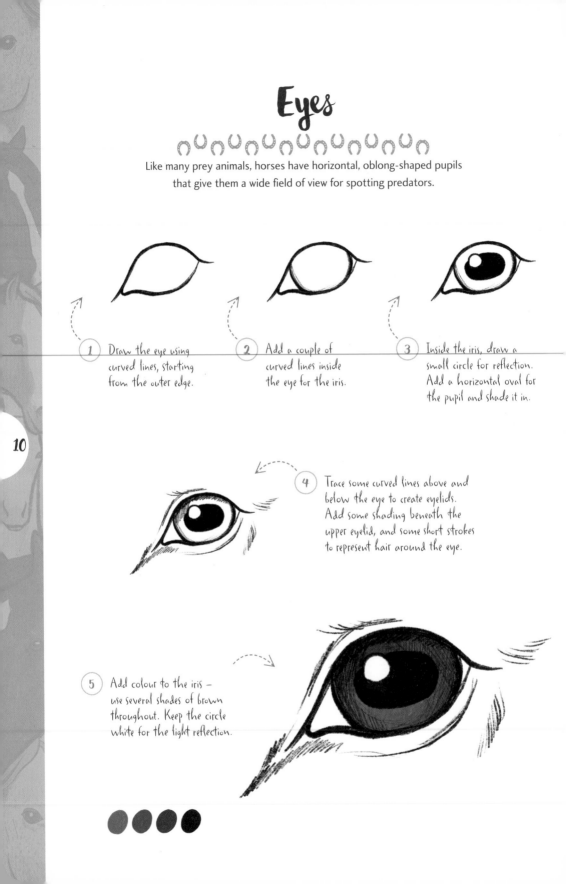

Like many prey animals, horses have horizontal, oblong-shaped pupils
that give them a wide field of view for spotting predators.

1) Draw the eye using
curved lines, starting
from the outer edge.

2) Add a couple of
curved lines inside
the eye for the iris.

3) Inside the iris, draw a
small circle for reflection.
Add a horizontal oval for
the pupil and shade it in.

4) Trace some curved lines above and
below the eye to create eyelids.
Add some shading beneath the
upper eyelid, and some short strokes
to represent hair around the eye.

5) Add colour to the iris –
use several shades of brown
throughout. Keep the circle
white for the light reflection.

Ears

Horses' ears are used to hear, but they are also used for communication, so they can tell you a lot about the horse's mood.

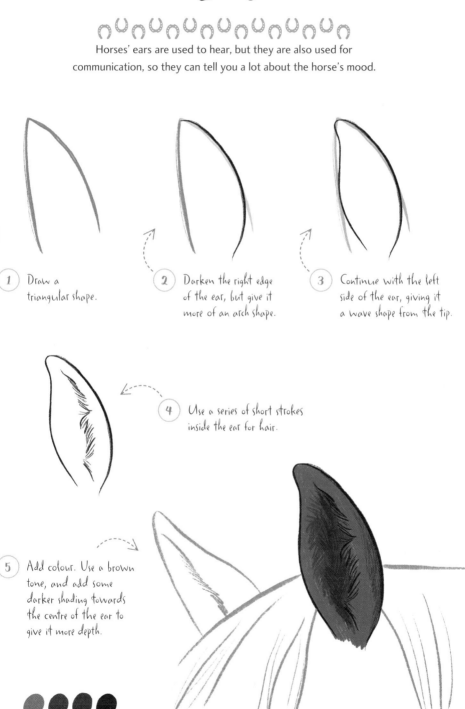

1. Draw a triangular shape.

2. Darken the right edge of the ear, but give it more of an arch shape.

3. Continue with the left side of the ear, giving it a wave shape from the tip.

4. Use a series of short strokes inside the ear for hair.

5. Add colour. Use a brown tone, and add some darker shading towards the centre of the ear to give it more depth.

Front head
Thoroughbred

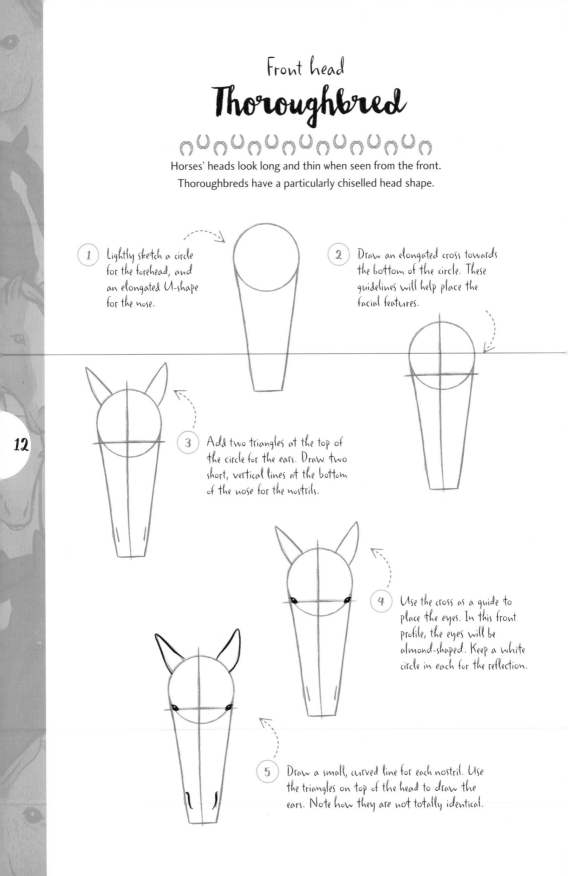

Horses' heads look long and thin when seen from the front.
Thoroughbreds have a particularly chiselled head shape.

1. Lightly sketch a circle for the forehead, and an elongated U-shape for the nose.

2. Draw an elongated cross towards the bottom of the circle. These guidelines will help place the facial features.

3. Add two triangles at the top of the circle for the ears. Draw two short, vertical lines at the bottom of the nose for the nostrils.

4. Use the cross as a guide to place the eyes. In this front profile, the eyes will be almond-shaped. Keep a white circle in each for the reflection.

5. Draw a small, curved line for each nostril. Use the triangles on top of the head to draw the ears. Note how they are not totally identical.

6. Trace the outline of the muzzle by following the guide but giving it more shape, as shown here.

7. Draw the forelock with a series of long, curved lines.

8. Finish the outline of the head. Add the upper and lower neck line.

9. Draw a 'stripe' marking on the forehead. Sketch the mane along the neck. Add some shading to the face and nostrils using very short strokes.

10. Add colour. Start with light brown on the face and neck, and add darker shading for depth. Leave the 'stripe' marking on the forehead white. Colour the mane in a light-tan tone and the muzzle in grey.

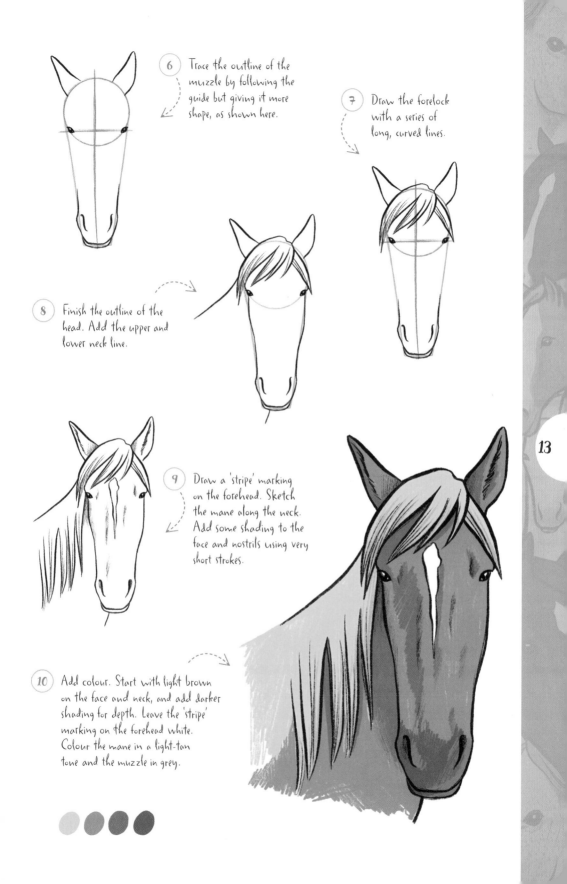

Exmoor Pony

Exmoor ponies have large, broad-shaped heads and relatively
small ears, with a thick, coarse coat.

1 Lightly sketch a circle for the face, and a U-shape for the nose.

2 Loosely sketch the top and bottom of the head and neck, making sure that it's fairly wide.

3 Add two triangles for the ears. Draw an oval for the nostril. Add a horizontal guideline across the circle, starting where the line of the nose meets it.

4 Draw the eye just above the guideline. Trace a comma-like shape for the nostril.

5 Add some shading to the nostril's opening. Trace the outline of the muzzle, including the mouth. Add some short strokes under the chin for hair.

14

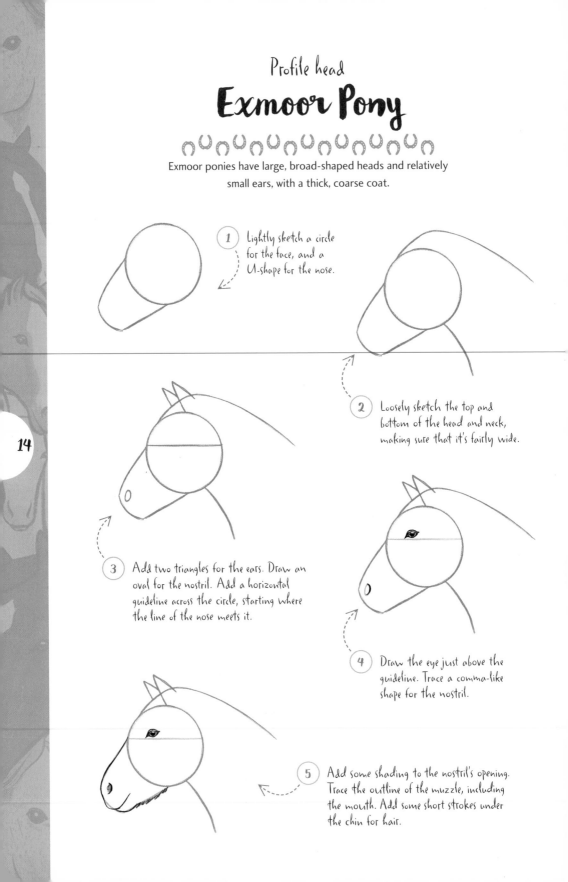

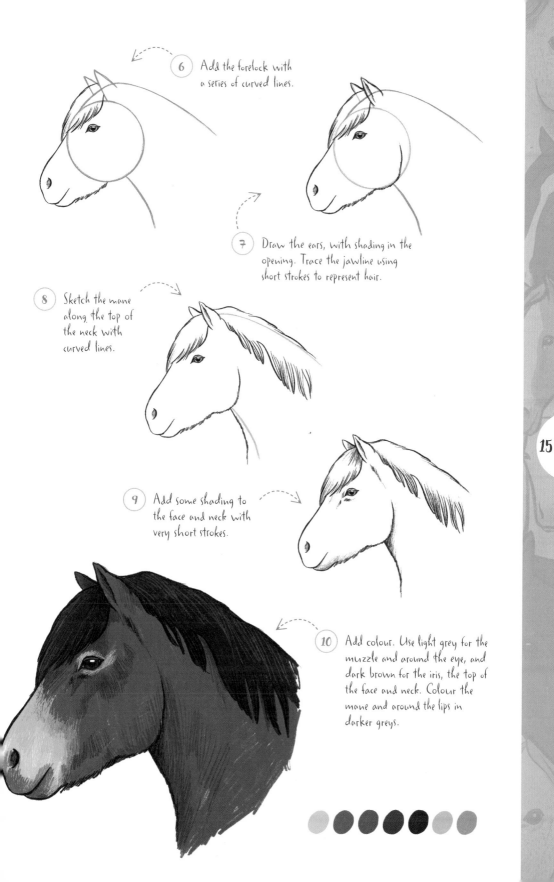

6 Add the forelock with a series of curved lines.

7 Draw the ears, with shading in the opening. Trace the jawline using short strokes to represent hair.

8 Sketch the mane along the top of the neck with curved lines.

9 Add some shading to the face and neck with very short strokes.

10 Add colour. Use light grey for the muzzle and around the eye, and dark brown for the iris, the top of the face and neck. Colour the mane and around the lips in darker greys.

Three-quarter profile
Percheron

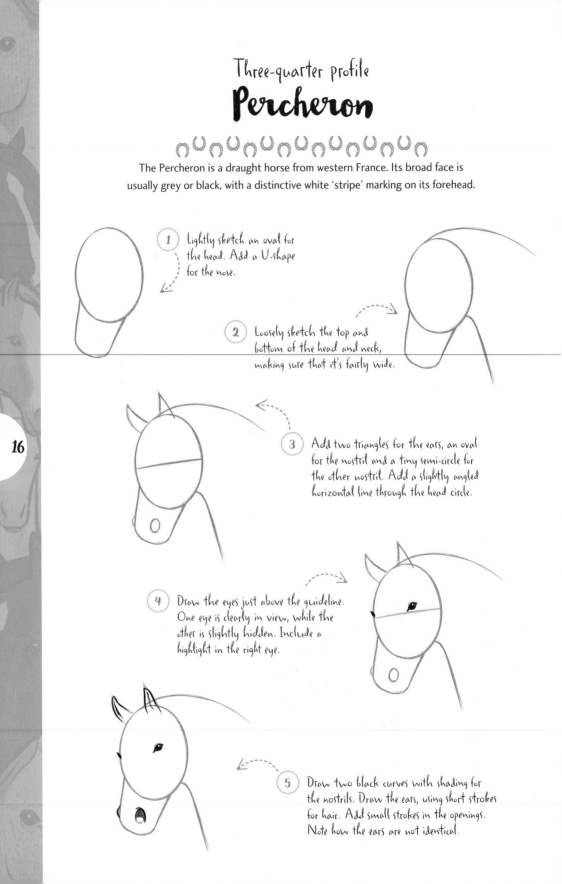

The Percheron is a draught horse from western France. Its broad face is usually grey or black, with a distinctive white 'stripe' marking on its forehead.

1 Lightly sketch an oval for the head. Add a U-shape for the nose.

2 Loosely sketch the top and bottom of the head and neck, making sure that it's fairly wide.

3 Add two triangles for the ears, an oval for the nostril and a tiny semi-circle for the other nostril. Add a slightly angled horizontal line through the head circle.

4 Draw the eyes just above the guideline. One eye is clearly in view, while the other is slightly hidden. Include a highlight in the right eye.

5 Draw two black curves with shading for the nostrils. Draw the ears, using short strokes for hair. Add small strokes in the openings. Note how the ears are not identical.

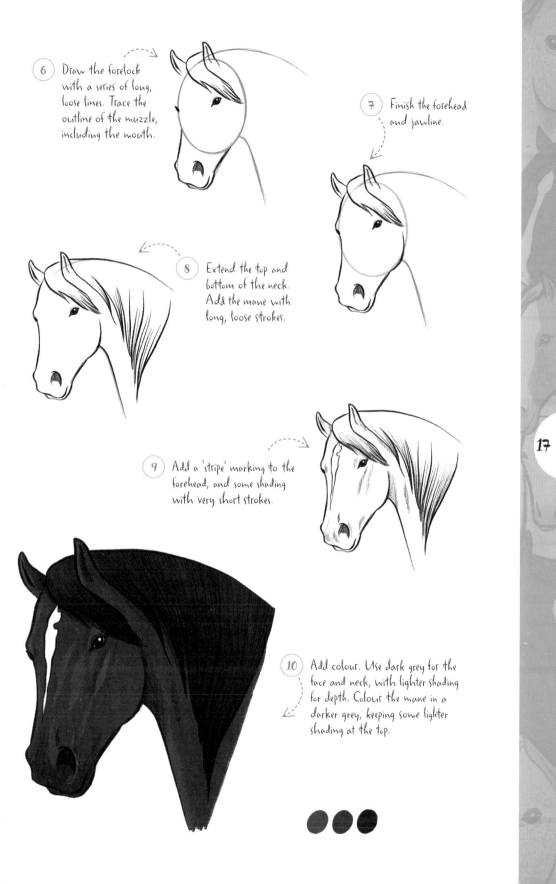

6 Draw the forelock with a series of long, loose lines. Trace the outline of the muzzle, including the mouth.

7 Finish the forehead and jawline.

8 Extend the top and bottom of the neck. Add the mane with long, loose strokes.

9 Add a 'stripe' marking to the forehead, and some shading with very short strokes.

10 Add colour. Use dark grey for the face and neck, with lighter shading for depth. Colour the mane in a darker grey, keeping some lighter shading at the top.

Three-quarter profile
Gypsy Vanner

Traditionally used by English and Irish Travellers, Gypsy Vanners are usually skewbald (brown and white) or piebald (black and white) in colour.

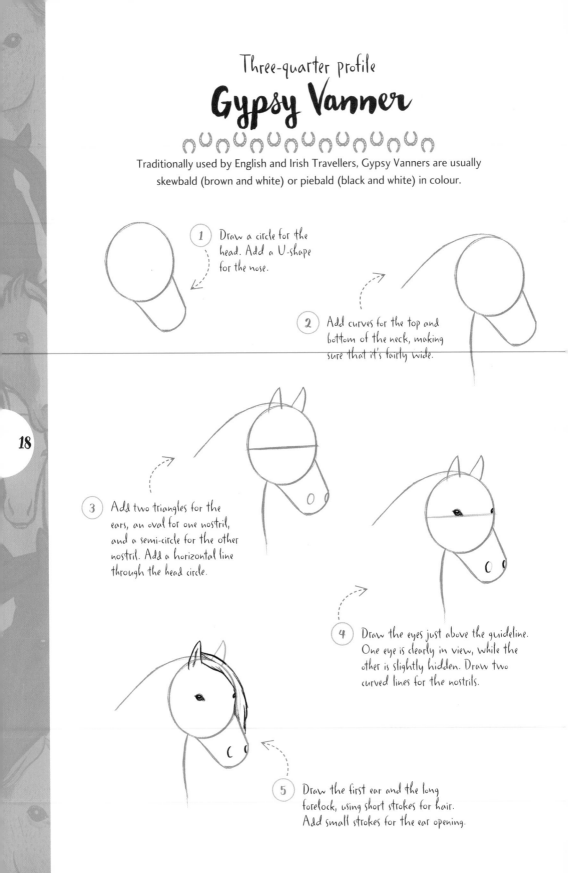

1 Draw a circle for the head. Add a U-shape for the nose.

2 Add curves for the top and bottom of the neck, making sure that it's fairly wide.

3 Add two triangles for the ears, an oval for one nostril, and a semi-circle for the other nostril. Add a horizontal line through the head circle.

4 Draw the eyes just above the guideline. One eye is clearly in view, while the other is slightly hidden. Draw two curved lines for the nostrils.

5 Draw the first ear and the long forelock, using short strokes for hair. Add small strokes for the ear opening.

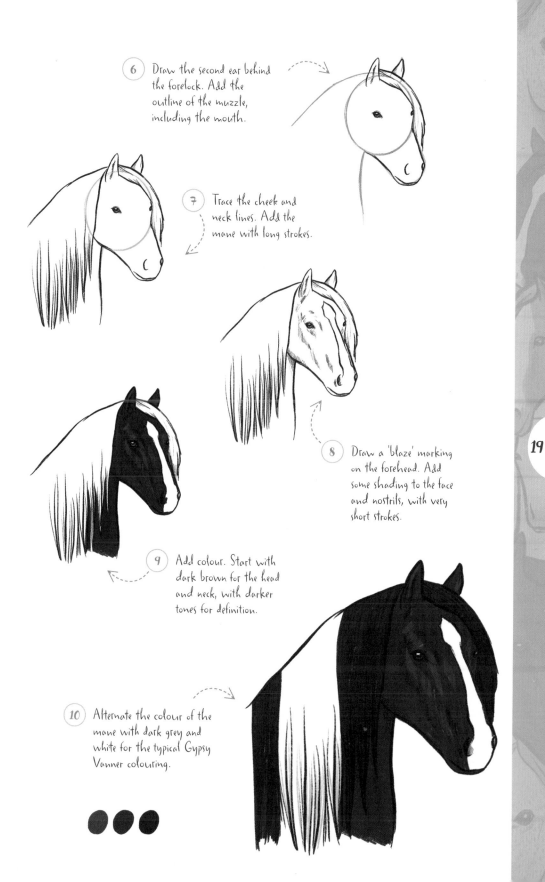

6 Draw the second ear behind the forelock. Add the outline of the muzzle, including the mouth.

7 Trace the cheek and neck lines. Add the mane with long strokes.

8 Draw a 'blaze' marking on the forehead. Add some shading to the face and nostrils, with very short strokes.

9 Add colour. Start with dark brown for the head and neck, with darker tones for definition.

10 Alternate the colour of the mane with dark grey and white for the typical Gypsy Vanner colouring.

19

Three-quarter profile
Arab

ᑎᑌᑎᑌᑎᑌᑎᑌᑎᑌᑎᑌᑎᑌᑎᑌᑎᑌᑎᑌᑎᑌᑎ

Arabs have a distinctive head shape, with a 'dished' face,
a relatively small muzzle and refined ears.

1 Sketch a loose circle for the head. Add a U-shape for the nose.

2 Sketch the top and bottom of the head and neck.

3 Add two curved triangles for the ears, and an oval for the nostril. Add a slightly angled horizontal line through the head circle.

4 Draw the eyes just above the guideline. One eye is clearly in view, while the other is slightly hidden.

5 Draw two curves for the nostrils, and add some shading in the openings. Draw the ears, using short strokes for hair. Add small strokes for the ear openings. Note how they are not identical.

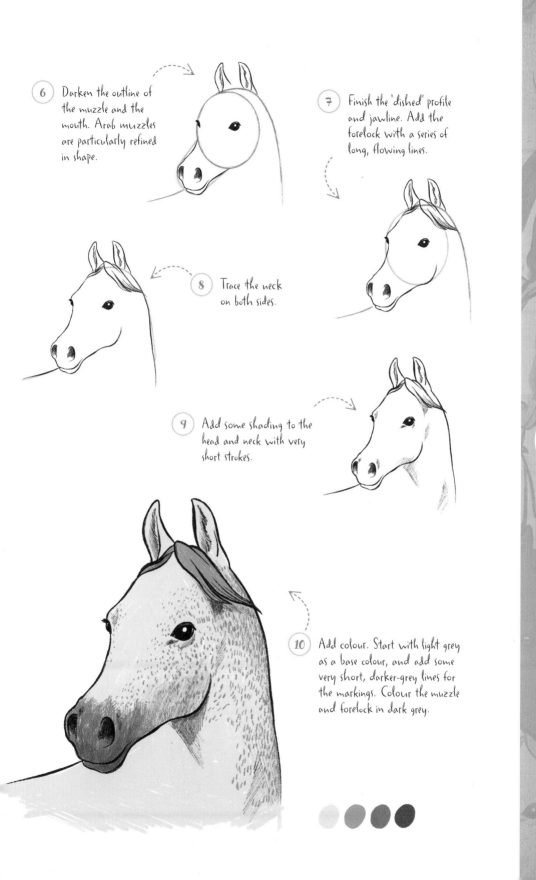

6 Darken the outline of the muzzle and the mouth. Arab muzzles are particularly refined in shape.

7 Finish the 'dished' profile and jawline. Add the forelock with a series of long, flowing lines.

8 Trace the neck on both sides.

9 Add some shading to the head and neck with very short strokes.

10 Add colour. Start with light grey as a base colour, and add some very short, darker-grey lines for the markings. Colour the muzzle and forelock in dark grey.

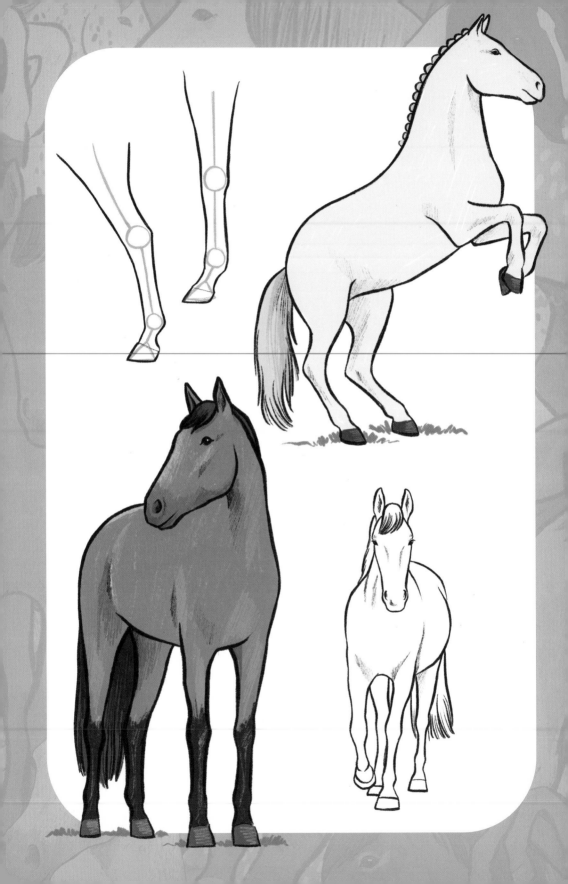

Horse & Pony Bodies

Front leg

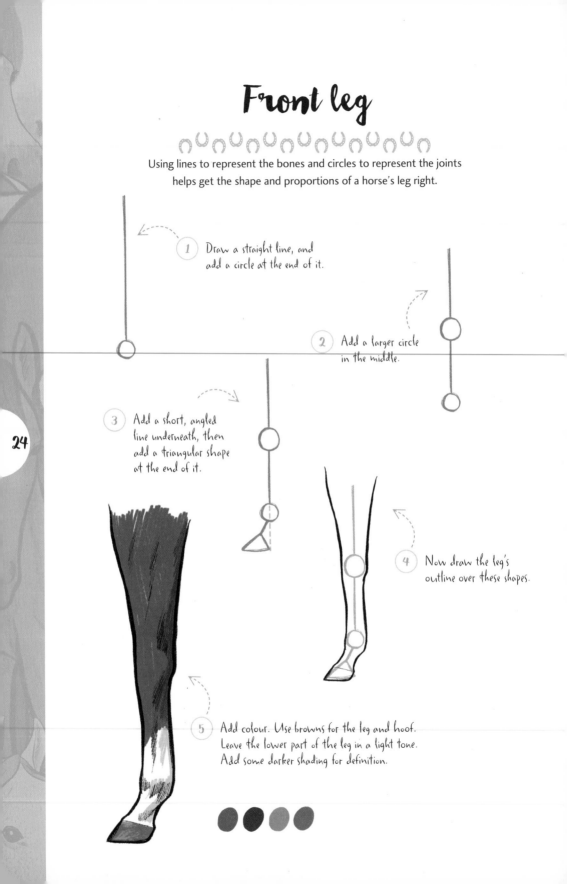

Using lines to represent the bones and circles to represent the joints helps get the shape and proportions of a horse's leg right.

1 Draw a straight line, and add a circle at the end of it.

2 Add a larger circle in the middle.

3 Add a short, angled line underneath, then add a triangular shape at the end of it.

4 Now draw the leg's outline over these shapes.

5 Add colour. Use browns for the leg and hoof. Leave the lower part of the leg in a light tone. Add some darker shading for definition.

Hind leg

These lines and circles in the hind leg represent, from top to bottom: the upper leg, hock joint, cannon bone, fetlock joint, pastern bone and a triangle for the hoof.

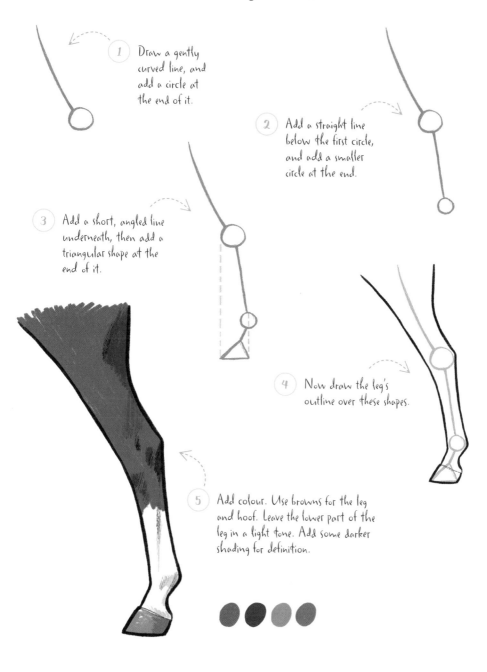

1. Draw a gently curved line, and add a circle at the end of it.

2. Add a straight line below the first circle, and add a smaller circle at the end.

3. Add a short, angled line underneath, then add a triangular shape at the end of it.

4. Now draw the leg's outline over these shapes.

5. Add colour. Use browns for the leg and hoof. Leave the lower part of the leg in a light tone. Add some darker shading for definition.

Profile body
American Saddlebred

Seen in side profile, it's no wonder the American Saddlebred is commonly found in show rings and Hollywood movies.

1 Draw two circles for the body, one slightly smaller than the other.

2 Connect the circles with curved lines. Draw a smaller circle as a guide for the head. This should be about one-fifth the size of the largest circle.

3 Draw a U-shape for the nose. Add two triangles on top of the head for the ears. Connect the head to the torso with two curved lines.

4 Add an angled line to the right for the tail. Add guidelines for the legs, including triangles for the hooves. Note their length compared to the body.

5 Use the head circle to position the eye. Add a curved line for the nostril, with a little shading in the opening. Trace the outline of the muzzle, including the mouth.

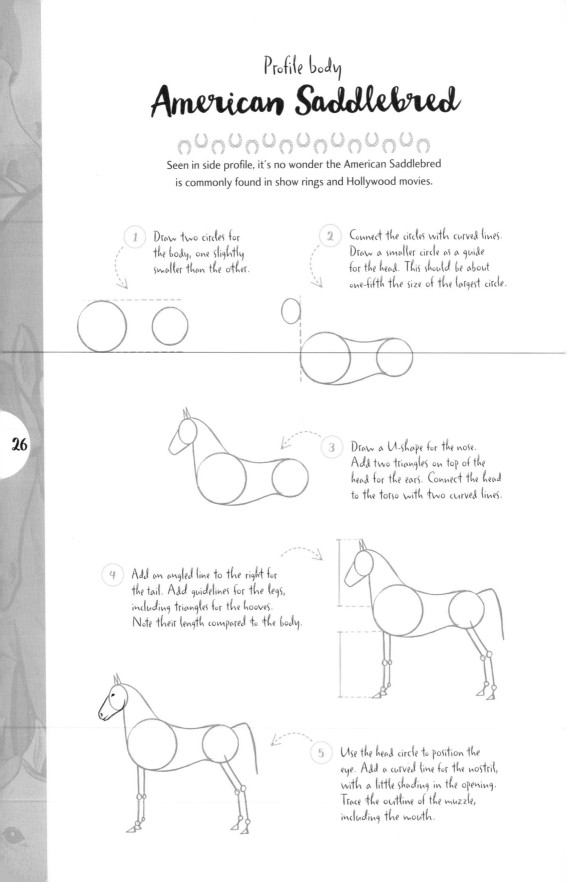

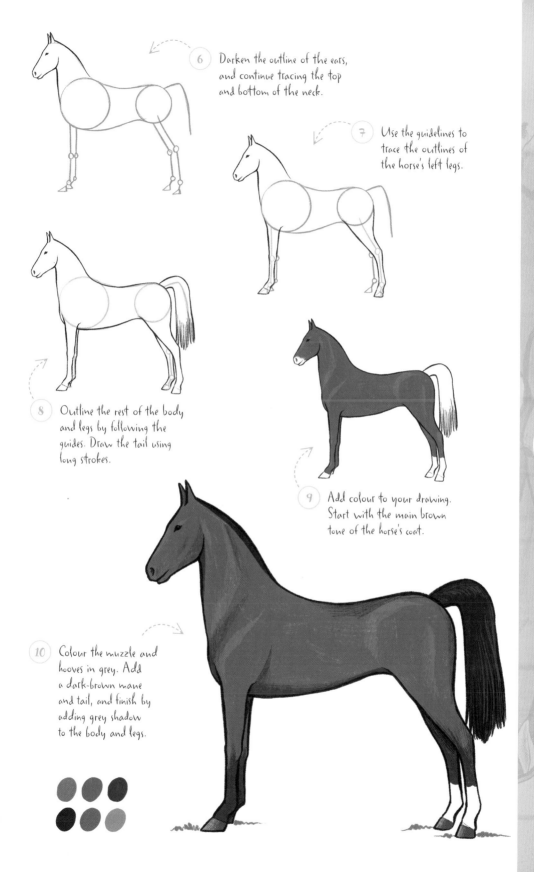

6 Darken the outline of the ears, and continue tracing the top and bottom of the neck.

7 Use the guidelines to trace the outlines of the horse's left legs.

8 Outline the rest of the body and legs by following the guides. Draw the tail using long strokes.

9 Add colour to your drawing. Start with the main brown tone of the horse's coat.

10 Colour the muzzle and hooves in grey. Add a dark-brown mane and tail, and finish by adding grey shadow to the body and legs.

Three-quarter profile
Lusitano

When drawing horses in a three-quarter profile, it's particularly helpful to plot the position of the head and body using simple shapes.

1 Draw two circles as guides for the head and chest. The head guide should be slightly left of the chest guide.

2 Add a U-shape to the lower left of the upper circle for the nose. Sketch two thin triangles on top of the head for the ears.

28

3 Connect the two circles with a curved line for the neck. Add a round curve to the left for the back portion of the body.

4 Add guidelines for the legs, including triangles for the hooves.

5 Use the head circle to position the eye. Add a curved line for the nostril, with a little shading in the opening. Trace the outline of the muzzle, including the mouth.

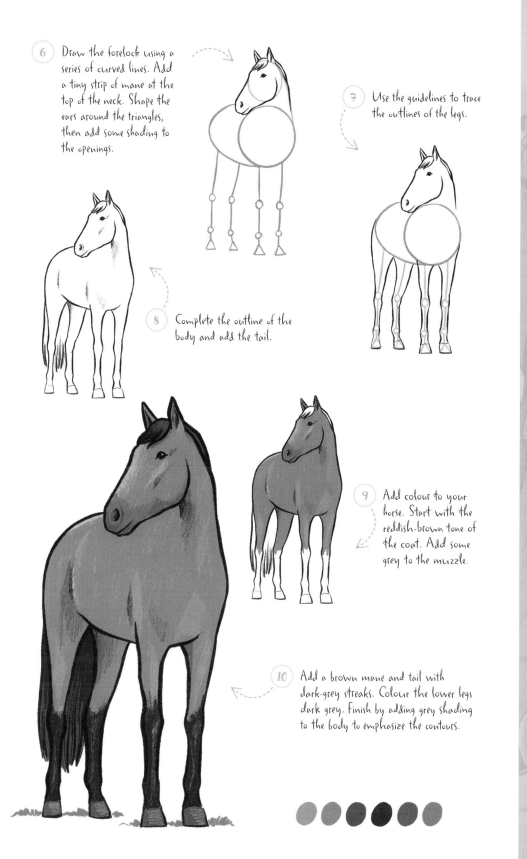

6 Draw the forelock using a series of curved lines. Add a tiny strip of mane at the top of the neck. Shape the ears around the triangles, then add some shading to the openings.

7 Use the guidelines to trace the outlines of the legs.

8 Complete the outline of the body and add the tail.

9 Add colour to your horse. Start with the reddish-brown tone of the coat. Add some grey to the muzzle.

10 Add a brown mane and tail with dark-grey streaks. Colour the lower legs dark grey. Finish by adding grey shading to the body to emphasize the contours.

Cleveland Bay

Drawing horses from the front is easy if you remember perspective – use the simple shapes to help!

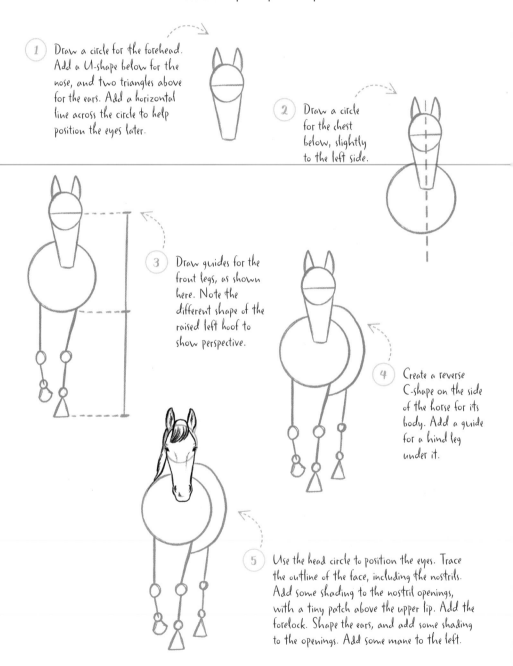

1. Draw a circle for the forehead. Add a U-shape below for the nose, and two triangles above for the ears. Add a horizontal line across the circle to help position the eyes later.

2. Draw a circle for the chest below, slightly to the left side.

30

3. Draw guides for the front legs, as shown here. Note the different shape of the raised left hoof to show perspective.

4. Create a reverse C-shape on the side of the horse for its body. Add a guide for a hind leg under it.

5. Use the head circle to position the eyes. Trace the outline of the face, including the nostrils. Add some shading to the nostril openings, with a tiny patch above the upper lip. Add the forelock. Shape the ears, and add some shading to the openings. Add some mane to the left.

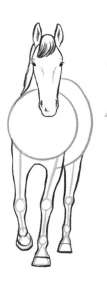

6 Use the guides under the body to create outlines for the legs.

7 Complete the body by following the outlines of the guides.

8 Add the outline of the fourth leg, and the tail at the back.

9 Colour the coat in brown, and the muzzle and lower parts of the legs in dark grey. The mane and tail can be a little darker.

10 Finish by adding some shading for definition.

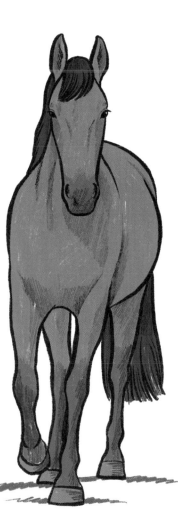

Rearing
Thoroughbred

A rearing horse makes a dramatic sight and drawing. Plot the position of the body and legs carefully, and the rest will be easy.

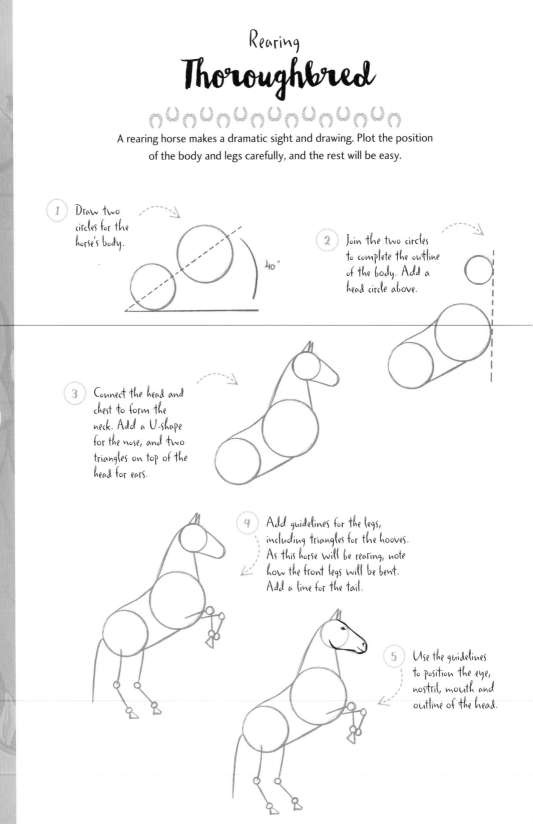

1 Draw two circles for the horse's body.

40°

2 Join the two circles to complete the outline of the body. Add a head circle above.

3 Connect the head and chest to form the neck. Add a U-shape for the nose, and two triangles on top of the head for ears.

4 Add guidelines for the legs, including triangles for the hooves. As this horse will be rearing, note how the front legs will be bent. Add a line for the tail.

5 Use the guidelines to position the eye, nostril, mouth and outline of the head.

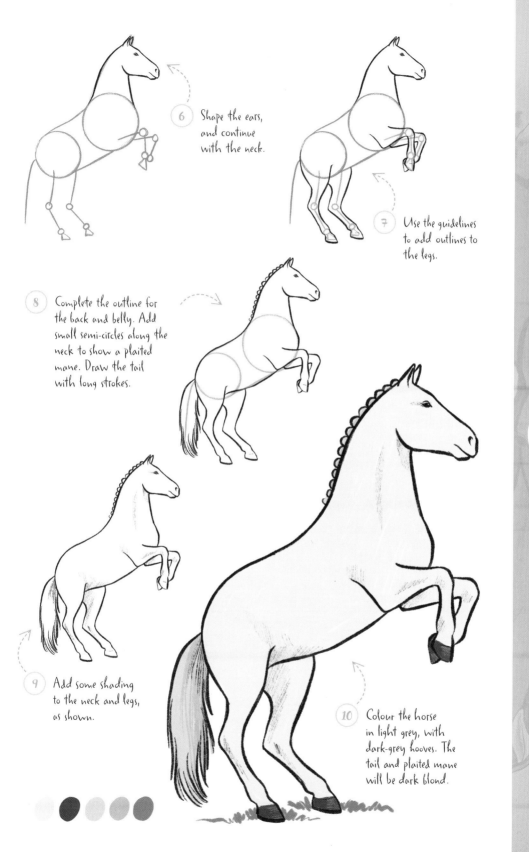

6 Shape the ears, and continue with the neck.

7 Use the guidelines to add outlines to the legs.

8 Complete the outline for the back and belly. Add small semi-circles along the neck to show a plaited mane. Draw the tail with long strokes.

9 Add some shading to the neck and legs, as shown.

10 Colour the horse in light grey, with dark-grey hooves. The tail and plaited mane will be dark blond.

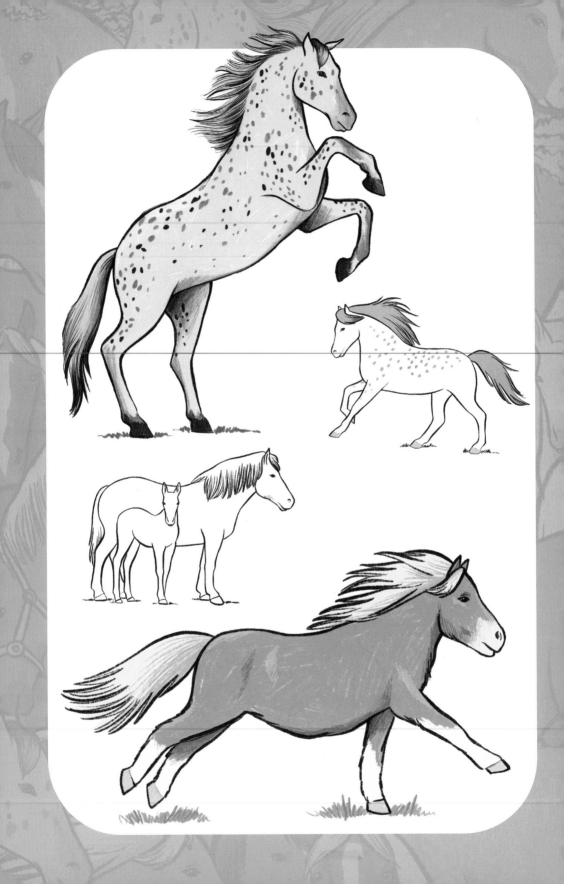

From North &
South America

Appaloosa

The magnificent Appaloosa is well known for its leopard-spotted coat.
Look carefully at how the front legs are bent in this rearing pose.

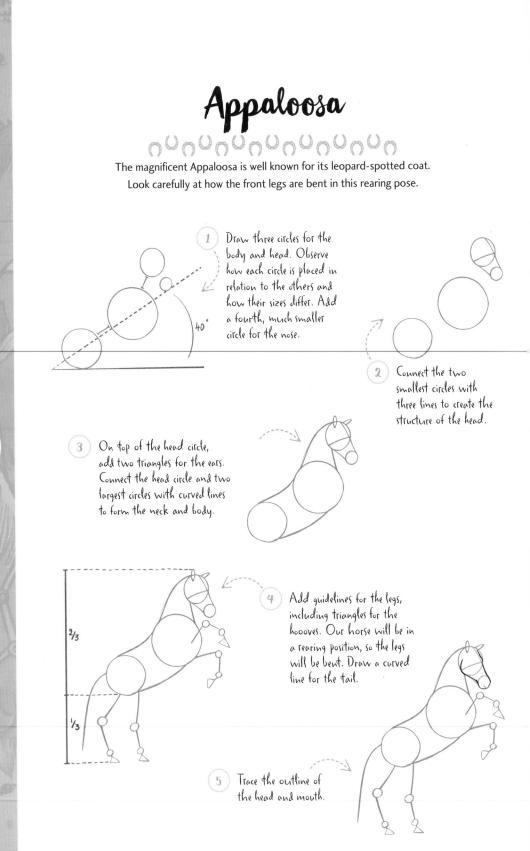

1 Draw three circles for the body and head. Observe how each circle is placed in relation to the others and how their sizes differ. Add a fourth, much smaller circle for the nose.

40°

2 Connect the two smallest circles with three lines to create the structure of the head.

3 On top of the head circle, add two triangles for the ears. Connect the head circle and two largest circles with curved lines to form the neck and body.

4 Add guidelines for the legs, including triangles for the hoooves. Our horse will be in a rearing position, so the legs will be bent. Draw a curved line for the tail.

2/3

1/3

5 Trace the outline of the head and mouth.

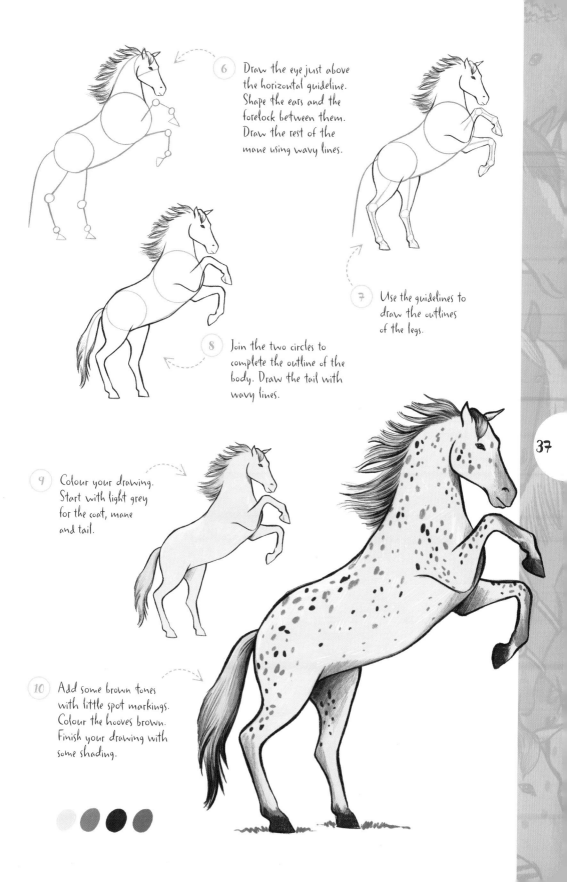

6　Draw the eye just above the horizontal guideline. Shape the ears and the forelock between them. Draw the rest of the mane using wavy lines.

7　Use the guidelines to draw the outlines of the legs.

8　Join the two circles to complete the outline of the body. Draw the tail with wavy lines.

9　Colour your drawing. Start with light grey for the coat, mane and tail.

10　Add some brown tones with little spot markings. Colour the hooves brown. Finish your drawing with some shading.

Bashkir Curly

As its name suggests, the Bashkir Curly has a curly coat and mane.
Experiment with some wavy lines and twirls to create this effect.

1. Draw two circles for the body, one slightly bigger than the other. Draw another circle for the head, and a U-shape for the nose.

2. Connect the circles with curved lines to form the neck and the body.

3. Draw two triangles on top of the head for the ears. Add guidelines for the legs, including triangles for the hooves.

4. Draw the eye in the middle of the circle guide. Trace the outline of the muzzle, including the mouth. Add the nostril.

5. Trace the ears, and add some shading inside the left one. Use the guidelines to trace the outline of the front leg. The top of the leg should be thicker.

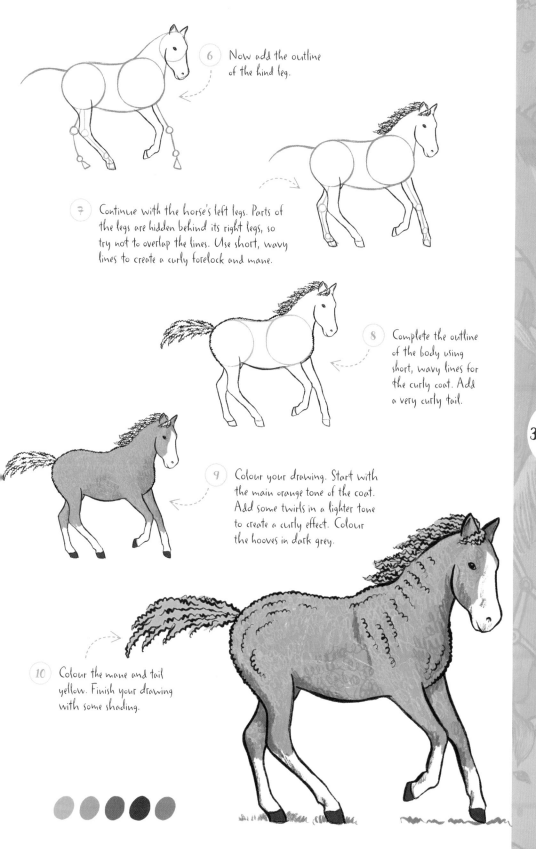

6 Now add the outline of the hind leg.

7 Continue with the horse's left legs. Parts of the legs are hidden behind its right legs, so try not to overlap the lines. Use short, wavy lines to create a curly forelock and mane.

8 Complete the outline of the body using short, wavy lines for the curly coat. Add a very curly tail.

9 Colour your drawing. Start with the main orange tone of the coat. Add some twirls in a lighter tone to create a curly effect. Colour the hooves in dark grey.

10 Colour the mane and tail yellow. Finish your drawing with some shading.

Morgan

The elegant Morgan has a distinctive, slightly dish-shaped head,
and carries its tail gracefully high behind it.

1. Draw two circles for the body, one slightly bigger than the other. Draw another circle for the head, and a U-shape for the nose.

2. Connect the circles with curved lines to form the neck and the body.

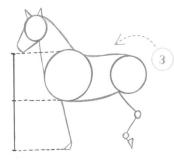

3. Draw two triangles on top of the head for the ears. Add guidelines for the horse's right legs, including triangles for the hooves. Note their relative length. The hind leg has two small circles, which correspond to bends at the knee and ankle joints. The front leg is straight.

4. Add guidelines for the horse's left legs. The front leg is raised, so draw two small circles to show bends at the knee and ankle joints. Add a curved tail guide.

5. Draw the eye in the middle of the circle guide. Trace the outline of the muzzle, including the mouth. Add the nostril.

6 Draw the ears, adding small lines for the openings. Complete the outline for the rest of the head. Use the guidelines to draw the outlines of the horse's left legs.

7 Continue with the horse's right legs. Part of the legs are hidden behind the left legs, so try not to overlap the lines. Draw the forelock and mane using curved lines. Point the curves to the right to show movement.

8 Join the two circles to complete the outline of the body. Draw the tail using curved lines.

9 Colour your drawing. Start with the bay (brown) colour of the horse's coat.

10 Add some dark brown for the mane and tail, and grey for the hooves. Finish with some shading.

American Quarter Horse

This champion sprinter has a compact and muscly body, well-suited to working livestock using its speed and agility.

1. Draw two circles for the chest and the head. The top circle should be half the size of the other. Add a small oval for the muzzle, one-fifth the size of the head circle.

2. Draw a diagonal line from the top of the head circle down to the top of the oval, as shown here. Add a curved line across the head circle.

3. Sketch a curved line on the left for the neck. Add a big arc to the right for the body, and a curved line for the tail.

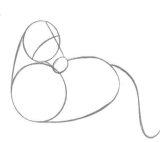

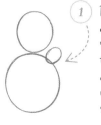

4. Draw two triangles on top of the head for the ears. Add guidelines for the legs, including triangles for the hooves. Note the angles of the hind hooves from the ankle joints.

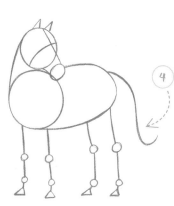

5. Draw the eye in the middle of the circle guide. Trace the outline of the muzzle, including the mouth. Add the nostril.

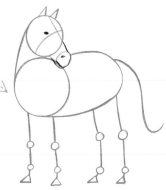

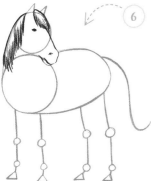

6 Draw the forelock and mane using loose lines.

7 Draw the ears, adding small strokes for the openings. Use the guidelines to trace the outlines of the legs.

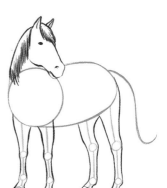

8 Complete the outline of the body. Draw the tail using wavy lines.

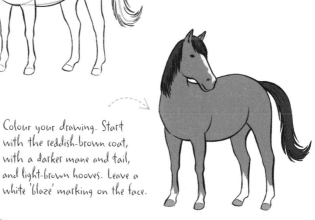

9 Colour your drawing. Start with the reddish-brown coat, with a darker mane and tail, and light-brown hooves. Leave a white 'blaze' marking on the face.

10 Finish your drawing with shading for definition.

Rocky Mountain Horse

Known for its distinctive chocolate coat with straw-coloured mane
and tail, this hardy horse from Kentucky is a joy to draw.

1. Draw two circles for the body, one slightly bigger
than the other. Draw another circle for the head,
a quarter the size of the larger circle.

2. Add a U-shape for the nose,
and two triangles for ears.

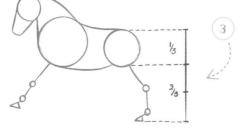

44

3. Connect the circles with curved lines
to form the neck and the body. Add
guidelines for the horse's left legs, including
triangles for the hooves. Note their relative
length, and the straight front leg.

4. Add guidelines for the horse's right
legs. The front leg is raised, so draw
two small circles to show bends at
the knee and ankle joints. Add a
tail guide.

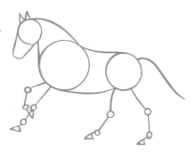

5. Use the head circle to position
the eye. Trace the outline
of the muzzle, including
the mouth. Add the nostril.

6 Draw the forelock and mane. Add the horse's
 ears and draw the outline of the neck. Trace
 the outlines of the horse's left legs.

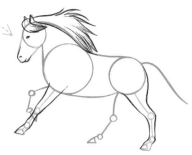

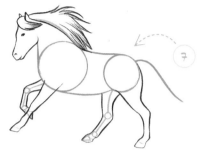

7 Complete the outline for the
 rest of the head. Continue
 with the right legs.

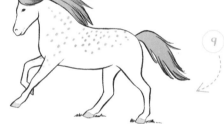

8 Complete the outline of the
 body. Draw the tail using
 wavy lines.

9 Add some colour. Start with
 a light-brown mane, tail and
 hooves. Add light-brown spot
 markings to the body.

10 Add a darker brown
 to the body around
 the spots. Keep a
 'blaze' marking on
 the forehead and the
 lower legs white.

Paso Fino

This handsome horse, whose name means 'fine step',
was brought to the Caribbean by Spanish settlers.

1 Draw two circles for the body, one slightly bigger than the other.

2 Draw another circle for the forehead with a U-shape for the nose below. Add an elongated cross. Sketch two wavy triangles for ears, and add two short, straight lines below for nostrils.

3 Connect the circles with curved lines to form the neck and the body. Add a tail guide.

4 Add guidelines for the legs, including triangles for the hooves.

5 Use the cross to position the eyes. Darken the outline of the muzzle, and add small curves for the nostrils.

46

6 Outline the rest of the head. Draw the ears, adding small strokes for the openings. Sketch the forelock and mane using slightly wavy strokes.

7 Use the guidelines to trace the outlines of the legs.

8 Complete the outline of the body. Draw the tail using curved lines.

9 Add colour. Start with the brown coat. Keep a white 'blaze' marking on the front of the face. Colour the mane and tail in a straw colour, and the hooves in light beige.

10 Add grey to the muzzle. Finish your drawing with shading for definition.

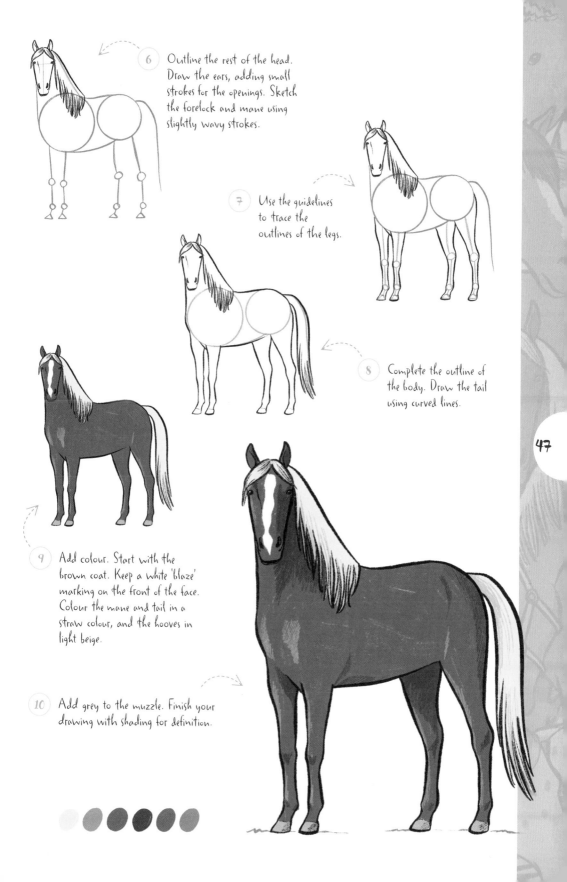

Criollo

Experiment with your coat colours on this small, hardy horse from
South America, but keep the markings small and subtle.

1. Draw two circles for the body, one slightly bigger
than the other. Draw another circle for the head,
a quarter the size of the larger circle.

2. Add a U-shape for the nose, and a
triangle for an ear. Add guidelines for
three of the horse's legs, including
triangles for the hooves.

3. Connect the head and larger body circle
using curved lines for the neck. Add some
guidelines to the head for the head collar.

4. Complete the outline for the body.
Add a long S-shape for the tail guide.

5. Use the head circle to position the eye.
Trace the outline of the muzzle, flat
against the ground to show grazing.
Add the mouth and nostril.

6 Darken the lines of the ear, and add a single line next to it for the second ear. Trace over the head collar guidelines. Add the mane in long strokes along the top of the neck.

7 Trace the outlines of the legs. Add the tail with curving lines.

8 Complete the outline for the body.

9 Add colour. Start with a cream base on the coat, and add a light-brown pattern. Leave a white 'blaze' marking on the face. Choose a colour for the head collar.

10 Add grey to the hooves and muzzle. Finish by adding grey shading to the body to emphasize the contours.

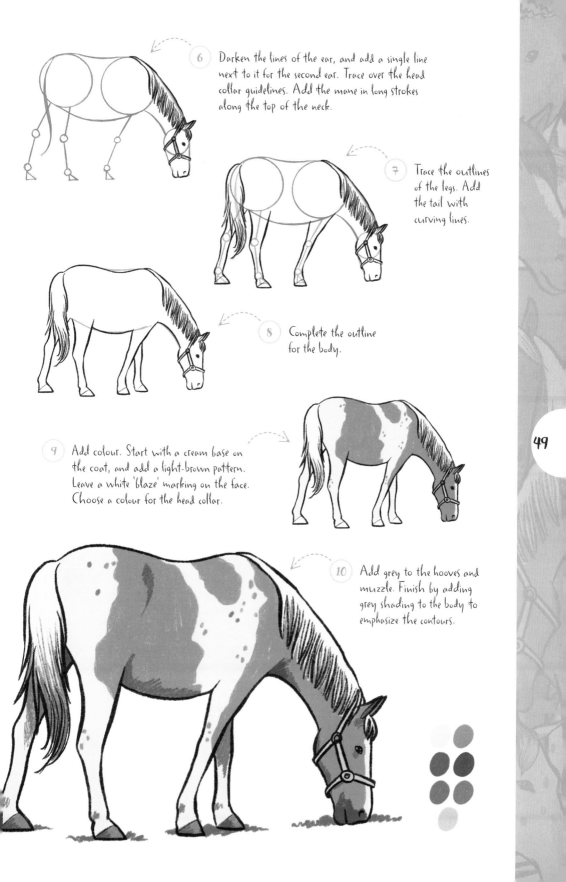

Falabella

This tiny horse from Argentina is perfectly proportioned.
Notice the thick mane and tail, and hair around the fetlocks.

1 Draw two circles for the body, one slightly bigger than the other, and position as shown here. Draw another circle for the head, one-third the size of the larger circle.

2 Add a U-shape to the head circle for the nose, and two triangles at the top for ears.

3 Connect the circles with curved lines to form the neck and the body. Add a long, curved tail guide.

4 Add guidelines for the legs, including triangles for the hooves. As our Falabella will be running, the legs will be raised at different heights. Note each line's position on the guide.

5 Use the head circle to position the eye. Trace the outline of the muzzle, including the mouth. Add the nostril, with a little shading for the opening.

6 Outline the rest of the head. Draw the forelock and mane using a series of slightly wavy lines. Add the tips of the ears above the forelock.

7 Use the guidelines to trace the outlines of the legs. Add some very short strokes at the backs of the legs to show the thick coat.

8 Complete the outline for the body. Draw the tail using wavy lines.

9 Colour the Falabella in light orange. Then add cream to the mane and muzzle, and a light tan to the hooves.

10 Finish your drawing with shading.

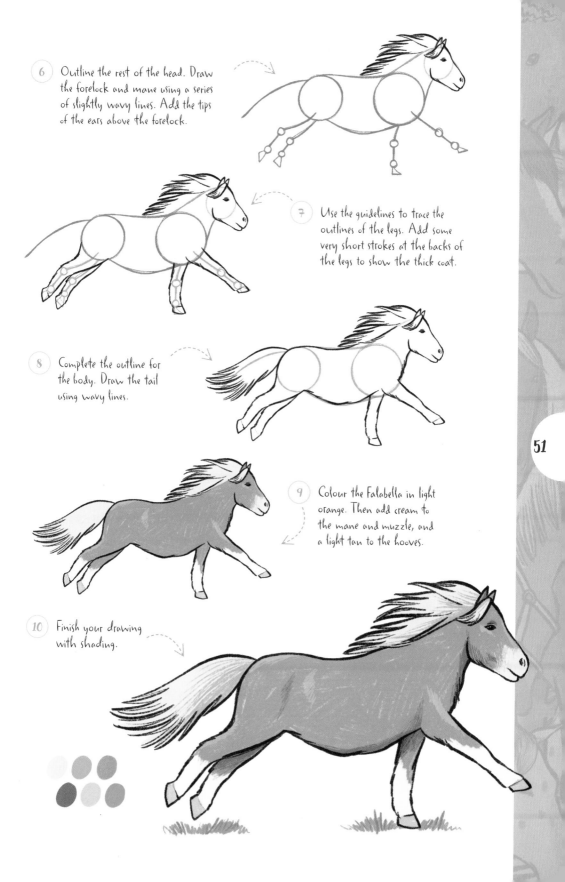

American Cream Draft

Practise your proportions and perspective with this classic mother and foal drawing, made easy with careful planning at the start.

1. Start with the foal. Draw two circles for the body, one slightly bigger than the other. Draw another, smaller circle for the head, about a quarter the size of the larger one.

2. Draw a U-shape for the foal's nose, overlapping the circle below. Add two triangles for the ears.

3. Connect the shapes with curved lines to form the foal's body. Add guidelines for the legs, including triangles for the hooves.

4. Now for the mother. Draw two big circles, one on each side of the foal.

5. Draw an oval for the mother's head. Add a U-shape for the muzzle, and a single triangle at the top for the ear. Connect the circles with curved lines. Draw guidelines for two of the mother's legs. Add a tail guide.

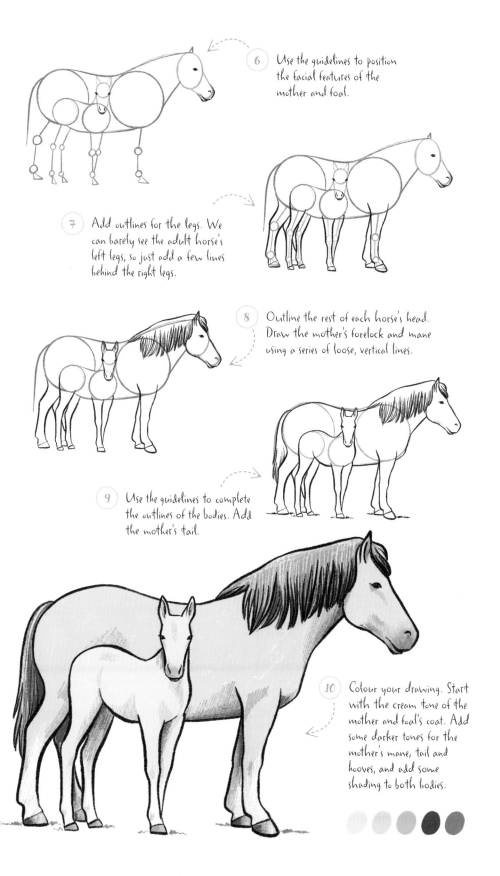

6　Use the guidelines to position the facial features of the mother and foal.

7　Add outlines for the legs. We can barely see the adult horse's left legs, so just add a few lines behind the right legs.

8　Outline the rest of each horse's head. Draw the mother's forelock and mane using a series of loose, vertical lines.

9　Use the guidelines to complete the outlines of the bodies. Add the mother's tail.

10　Colour your drawing. Start with the cream tone of the mother and foal's coat. Add some darker tones for the mother's mane, tail and hooves, and add some shading to both bodies.

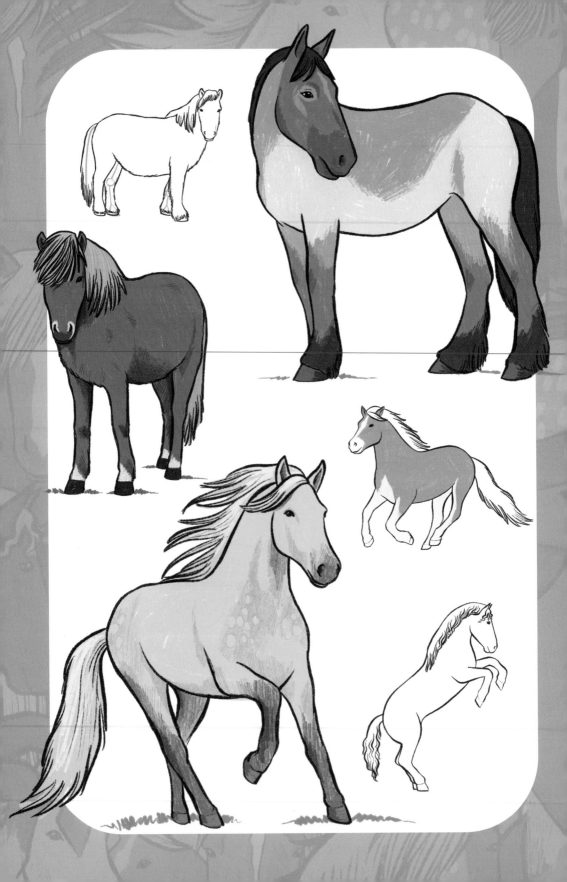

From Europe

Haflinger

This small, refined horse is from Austria and northern Italy. Haflingers are always chestnut (reddish-brown) in colour, with a cream mane and tail.

1 Draw two circles for the body, one slightly bigger than the other. Draw another circle for the head, a quarter the size of the larger circle.

2 Add two triangles on top of the head for ears, and a U-shape for the nose.

3 Connect the circles with curved lines to form the neck and the body. Add a curved line for the tail.

4 Add guidelines for three of the horse's legs, including triangles for the hooves.

5 Use the head circle to position the eye. Trace the outline of the muzzle, including the mouth. Add the nostril, with a little shading in the opening.

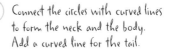

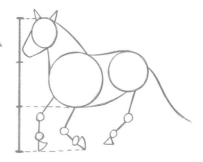

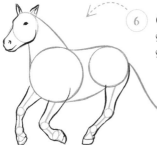

6 Outline the rest of the head, making the profile slightly dish-shaped. Draw the ears, adding small strokes for the openings. Trace the outlines of the legs.

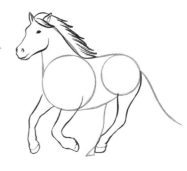

7 Add a guideline for the last leg – it should be placed a little in front of the existing hind leg. Draw the forelock and mane using wavy lines.

8 Complete the outline of the body, and the last leg. One of the hind legs is behind the other, so be careful not to overlap the lines. Draw the tail using wavy lines.

9 Add a reddish-brown colour to the coat, with a cream chest and legs. Leave a white 'blaze' marking on the face.

10 Add some cream to the mane and tail, and some dark brown to the muzzle. Finish with shading.

Noriker

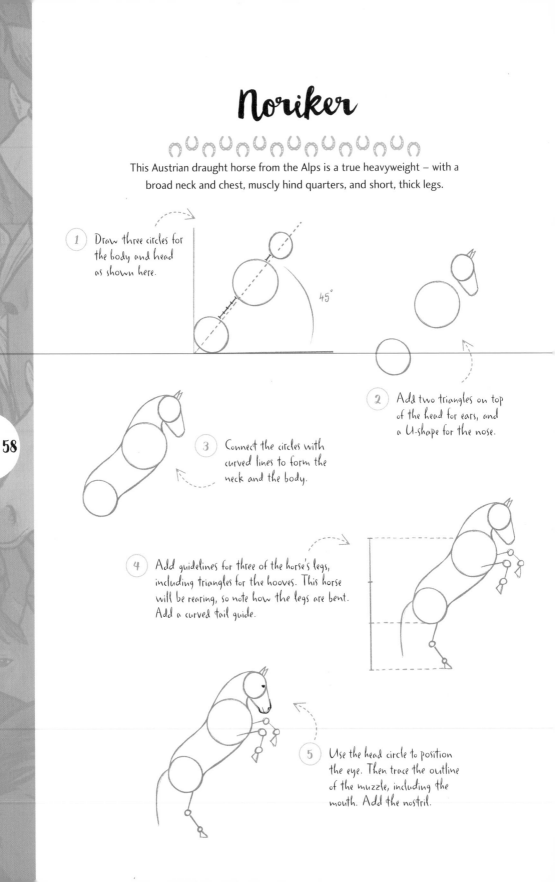

This Austrian draught horse from the Alps is a true heavyweight – with a broad neck and chest, muscly hind quarters, and short, thick legs.

1 Draw three circles for the body and head as shown here.

2 Add two triangles on top of the head for ears, and a U-shape for the nose.

3 Connect the circles with curved lines to form the neck and the body.

4 Add guidelines for three of the horse's legs, including triangles for the hooves. This horse will be rearing, so note how the legs are bent. Add a curved tail guide.

5 Use the head circle to position the eye. Then trace the outline of the muzzle, including the mouth. Add the nostril.

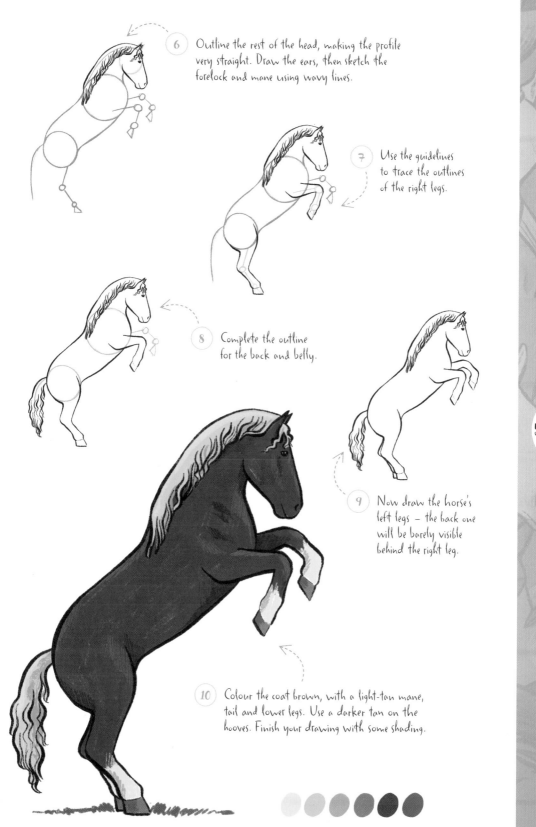

6 Outline the rest of the head, making the profile very straight. Draw the ears, then sketch the forelock and mane using wavy lines.

7 Use the guidelines to trace the outlines of the right legs.

8 Complete the outline for the back and belly.

9 Now draw the horse's left legs – the back one will be barely visible behind the right leg.

10 Colour the coat brown, with a light-tan mane, tail and lower legs. Use a darker tan on the hooves. Finish your drawing with some shading.

Belgian

A huge horse measuring up to 17 hands (173cm/68in), the Belgian is the strongest draught horse of all, bred to pull enormous weights.

1. Draw a circle for the head. Add a U-shape for the nose.

2. Draw a second circle for the chest. Draw a third circle to the right, for the back of the horse.

3. Join the two circles for the back and the belly. Add a curved line on the left for the neck.

4. Draw two triangles for the ears. Add guidelines for two of the horse's legs, including triangles for the hooves. Add a curved tail guide.

5. Continue with the horse's right legs. The front-right hoof is hidden behind the other front hoof, so there is no need to draw its triangle guide.

6 Draw the eye in the middle of the head circle. Trace the outline of the muzzle, including the mouth. Add the nostril.

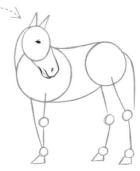

7 Draw the ears, adding small strokes for the openings. Add the forelock and mane using loose, curved lines. Trace the outlines of the left legs, using wavy lines on the fetlocks (above the hooves) to show long hair.

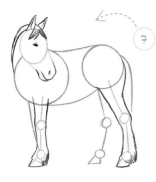

8 Continue with the horse's right legs. Draw the tail using wavy lines.

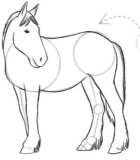

61

9 Colour the horse. Start with a brown for the coat, with a lighter tone on the underside.

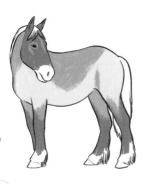

10 Add grey to the muzzle and hooves. Colour the mane, tail and fetlocks dark brown.

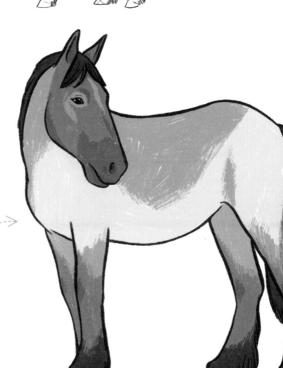

Brabant

A close relative of the Belgian, the Brabant is generally shorter and thicker-boned than its cousin.

1. Draw two circles for the body, one very slightly bigger than the other, and position as shown here. Draw another circle for the head, one-fifth the size of the larger circle.

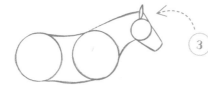

2. Add a very thin triangle on top of the head for an ear, and a U-shape for the nose.

3. Connect the circles with curved lines to form the neck and the body.

4. Add guidelines for the legs, including triangles for the hooves. Pay attention to the shape and length of each leg to get the horse's movement right. Add a guide for the tail.

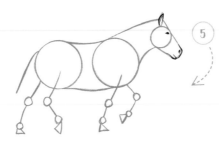

5. Darken the outline of the ear, adding a short line for the opening. Draw the eye in the top-right of the head circle. Trace the outline of the muzzle, including the mouth. Add the nostril.

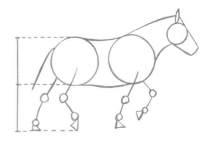

6 Outline the rest of the head. Draw the forelock in front of the ear, and the mane using a series of curved strokes.

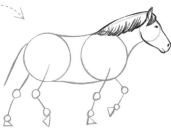

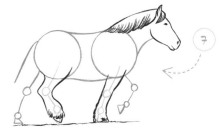

7 Use the guidelines to trace the outlines of the horse's right legs. The Brabant horse's legs are very muscular, and their hooves are tough, round and large. Use curved strokes above the hooves to represent the long fur.

8 Complete the outline of the body. Draw the tail using wavy lines.

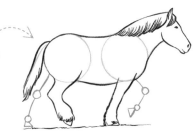

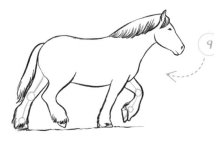

9 Continue with the horse's left legs.

10 Colour your horse's coat brown, with a dark-grey mane, tail and hooves. Finally, add some shading.

Connemara Pony

This hardy pony from western Ireland is a popular breed for competitions, including dressage, showjumping and eventing.

1 Draw two circles for the body, one very slightly bigger than the other, and position as shown here. Draw another circle for the head, one-third the size of the larger circle.

2 Add two triangles on top of the head for ears, and a U-shape for the nose.

3 Connect the circles with curved lines to form the neck and the body.

4 Add guidelines for two of the horse's legs, including triangles for the hooves. Note their length in relation to the body.

5 Add guidelines for the other two legs, noting how each is bent. Add an angled tail guide to the left.

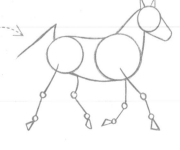

6 Draw the eye in the middle of the head circle. Trace the outline of the muzzle, including the mouth. Add the nostril, and outline the ears.

7 Outline the rest of the head, dipping the top edge slightly. Draw the forelock and mane using wavy lines. Trace the outlines of the horse's right legs.

8 Continue with the horse's left legs.

9 Add some base colour to your drawing. Start with the main light-grey tone of the horse's coat. Then add some white markings.

10 Add some darker grey to the mane, tail, lower legs and hooves. Finish your drawing with shading of the muzzle, neck and upper legs.

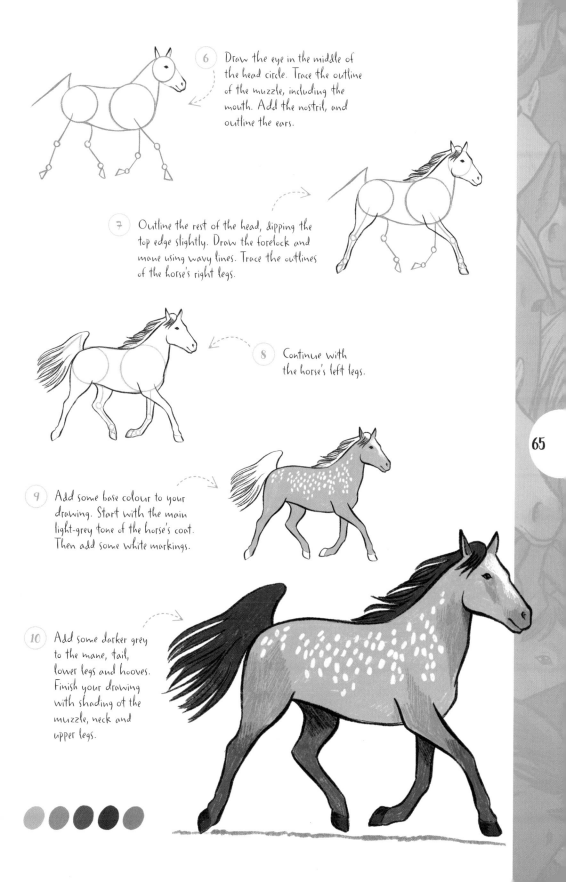

Jutland

This draught horse from Denmark usually has a chestnut-coloured coat,
but it can be black, white or brown.

(1) Draw a circle for the
head, and a U-shape for
the nose.

(2) Add the head guidelines as
two lines crossing through
the shapes. Draw two small
lines for the nostrils, and
add two triangles for ears.

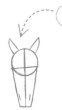

(3) Draw a large circle that will become
the horse's chest, using the guide for
positioning. Add a U-shape to its
left for the rest of the body.

(4) Connect the head and chest with
a curved line for the neck. Add
guidelines for the legs, including
triangles for the hooves. Note their
length in relation to the head.

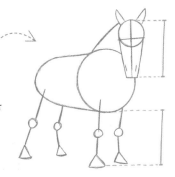

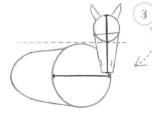

(5) Draw the forelock between the ears,
falling to one side. Add the horse's left
eye, and small curves for the nostrils.

6) Outline the rest of the head. Draw the ears, adding small strokes for the openings. Then sketch the rest of the mane using a series of wavy lines.

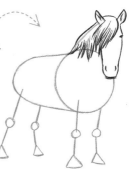

7) Use the guidelines to trace the outlines of the legs. The Jutland horse is a draught horse breed, so add some long hair above its hooves, and make them quite chunky.

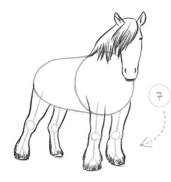

8) Complete the outline of the body.

9) Add the tail. Colour the coat in a reddish-brown tone, but leave the lower part of the legs and a 'blaze' marking on the face white.

10) Colour the mane, tail and lower legs light brown, and the hooves the same as the coat. Finish your drawing with shading.

Camargue

The Carmargue is believed to be one of the world's oldest breeds.
Born with a dark coat, its hair becomes white as it reaches adulthood.

1. Draw two circles for the body, one very slightly bigger than the other. Add another circle for the head, a quarter the size of the larger circle.

2. Connect the circles with curved lines to form the neck and the body. Add a U-shape for the nose.

3. Draw two triangles for the ears. Add guidelines for the horse's right legs, including triangles for the hooves. Both legs are raised, so note the angles at the knee and ankle joints.

4. Add guidelines for the second hind leg. Draw a tail guide.

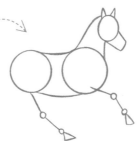

5. Draw the eye in the centre-left of the head circle. Trace the outline of the muzzle, including the mouth. Add the nostril, with a little shading in the opening.

6 Outline the rest of the head and ears, with a little shading in the openings. Add the flowing forelock and mane with curved strokes, showing the direction of movement.

7 Use the guidelines to trace the outlines of the legs. As the horse is starting to turn towards us, its right hind leg is not completely side on.

8 Complete the outline of the body.

9 Add the horse's front left leg behind its right one. Draw the tail using wavy lines.

10 Colour your horse. Start with the main off-white tone of its coat. Add light grey to the muzzle, mane, tail and hooves. Finish your drawing with shading.

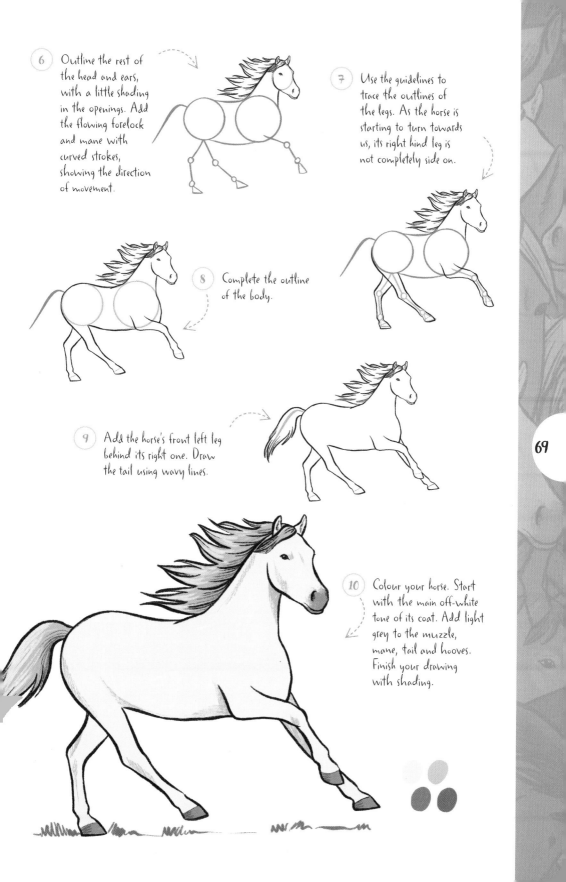

Selle Français

This prize-winning horse excels at showjumping and other competitive sports. It is usually brown or reddish-brown in colour.

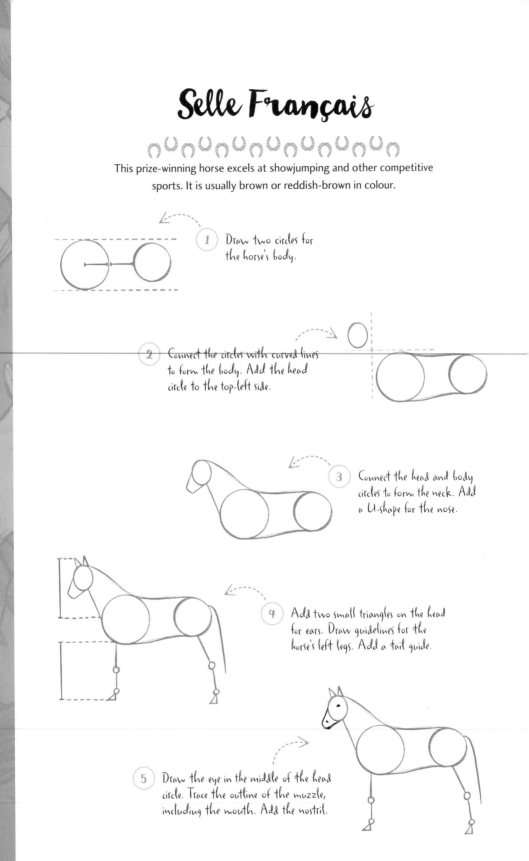

1. Draw two circles for the horse's body.

2. Connect the circles with curved lines to form the body. Add the head circle to the top-left side.

3. Connect the head and body circles to form the neck. Add a U-shape for the nose.

4. Add two small triangles on the head for ears. Draw guidelines for the horse's left legs. Add a tail guide.

5. Draw the eye in the middle of the head circle. Trace the outline of the muzzle, including the mouth. Add the nostril.

6 Outline the rest of the head, dipping the top edge to make it slightly dish-shaped in profile. Use the guidelines to trace the outlines of the horse's left legs.

7 Draw the plaited mane as little balls along the top of the neck, with one between the ears.

8 Use the remaining guides to draw the rest of the horse's body and its tail. Add the right legs' guidelines, keeping in mind that their top part will be hidden behind the left legs.

9 Trace the horse's right legs, and add some shading to the body and head.

10 Colour your horse in a brown shade, but keep the ankles white. The horse's tail will be dark brown. Add a little bit of grey around the eye and at the tip of the muzzle.

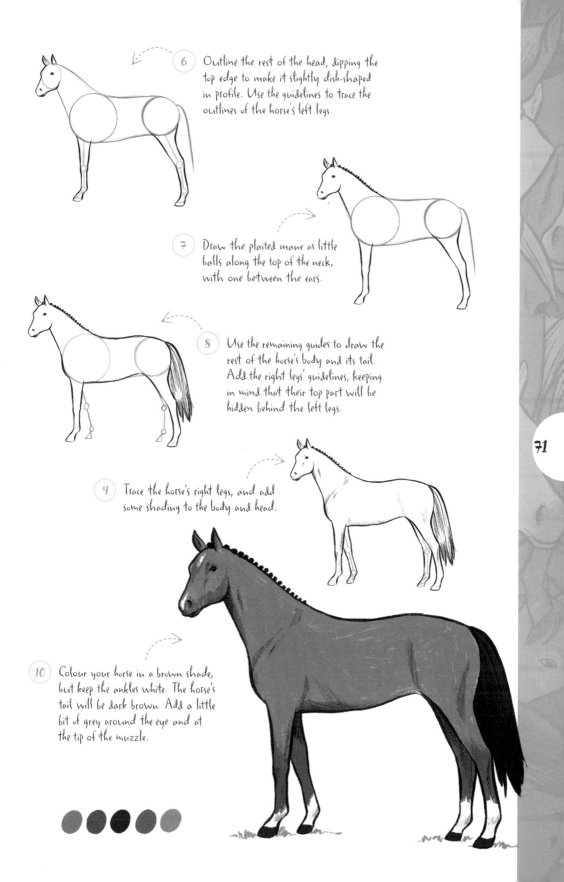

Hanoverian

This elegant, athletic horse is a champion in competitions including dressage, showjumping and eventing.

1. Draw two circles for the horse's body. Note their sizes and positioning.

60°

2. Add two smaller circles for the head and muzzle above the body circles.

3. Connect all the circles with curved lines to form the head, neck and body.

2/3

1/3

4. Draw a small triangle on the head for the ear. Add guidelines for the horse's right legs, including triangles for the hooves. Draw a tail guide.

5. Draw the eye towards the top of the head circle. Trace the outline of the muzzle, including the mouth. Add the nostril.

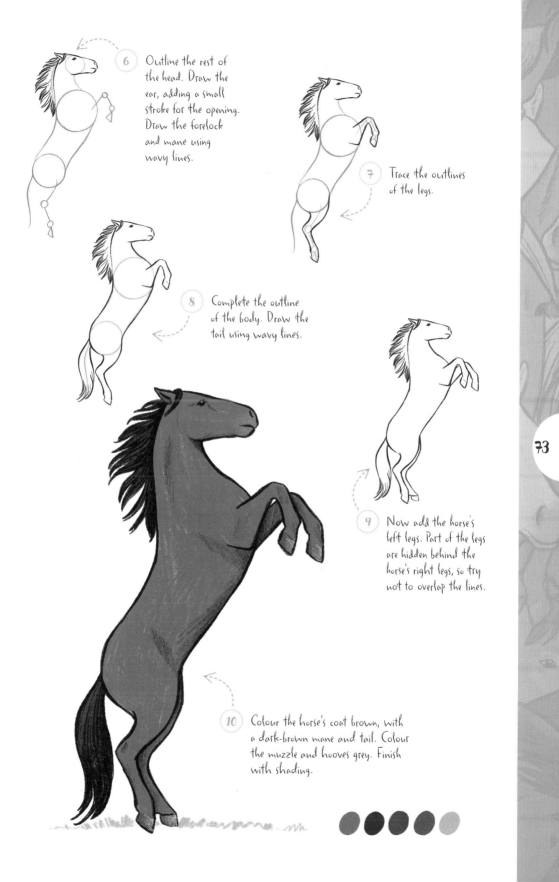

6 Outline the rest of the head. Draw the ear, adding a small stroke for the opening. Draw the forelock and mane using wavy lines.

7 Trace the outlines of the legs.

8 Complete the outline of the body. Draw the tail using wavy lines.

9 Now add the horse's left legs. Part of the legs are hidden behind the horse's right legs, so try not to overlap the lines.

10 Colour the horse's coat brown, with a dark-brown mane and tail. Colour the muzzle and hooves grey. Finish with shading.

Oldenburger

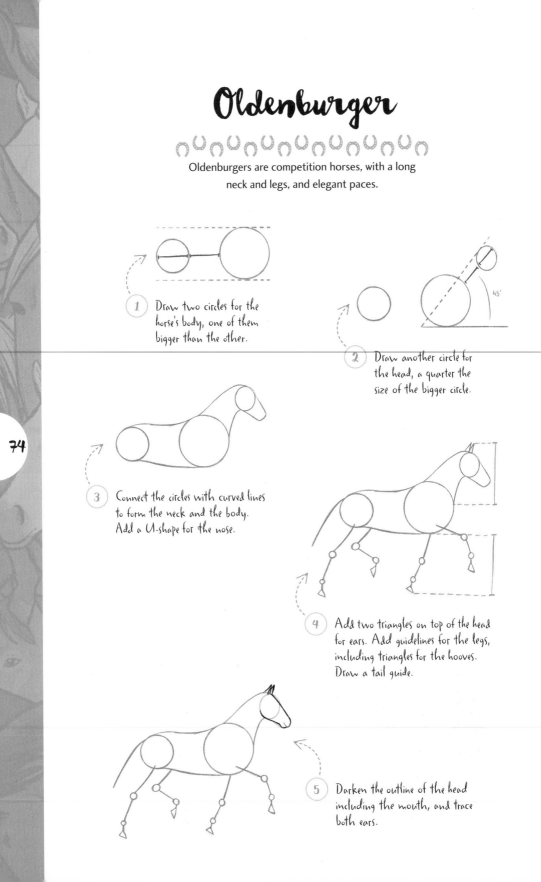

Oldenburgers are competition horses, with a long neck and legs, and elegant paces.

1. Draw two circles for the horse's body, one of them bigger than the other.

2. Draw another circle for the head, a quarter the size of the bigger circle.

45°

3. Connect the circles with curved lines to form the neck and the body. Add a U-shape for the nose.

4. Add two triangles on top of the head for ears. Add guidelines for the legs, including triangles for the hooves. Draw a tail guide.

5. Darken the outline of the head including the mouth, and trace both ears.

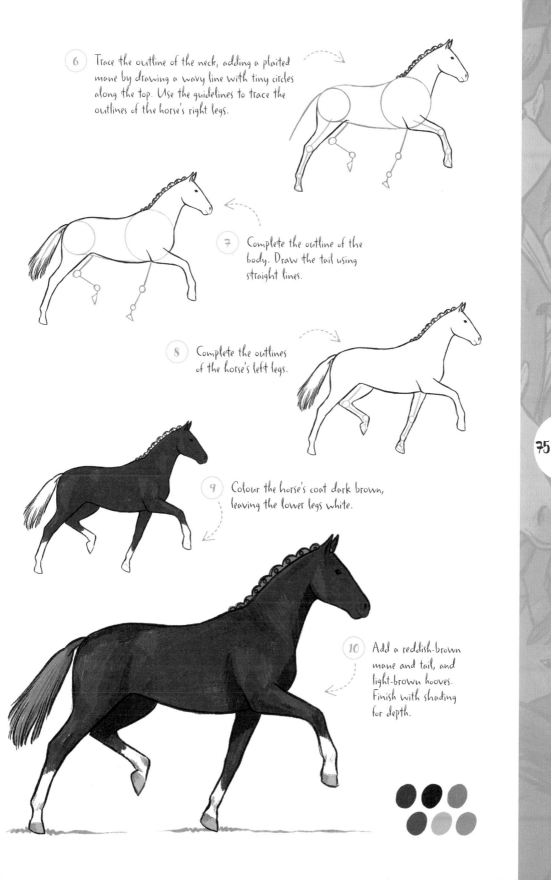

6. Trace the outline of the neck, adding a plaited mane by drawing a wavy line with tiny circles along the top. Use the guidelines to trace the outlines of the horse's right legs.

7. Complete the outline of the body. Draw the tail using straight lines.

8. Complete the outlines of the horse's left legs.

9. Colour the horse's coat dark brown, leaving the lower legs white.

10. Add a reddish-brown mane and tail, and light-brown hooves. Finish with shading for depth.

Trakehner

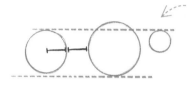

This elegant and intelligent Thoroughbred excels in dressage, where its paces can give the impression of it floating over the ground.

1. Draw two circles for the horse's body, one slightly bigger than the other. Add a third circle to the right for the head.

2. Add a U-shape for the nose. Connect the circles with curved lines to form the neck and the body.

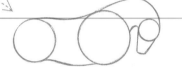

3. Add guidelines for the horse's right legs, including triangles for the hooves. Note their relative lengths, and how the back leg will be bent, and the front one straight.

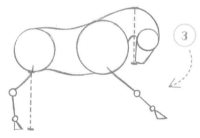

4. Draw the guidelines for the horse's left legs. Add a triangle on top of the head for one ear, and a curve on the left for the tail.

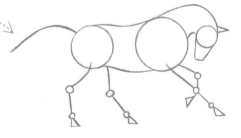

5. Draw the eye at the bottom of the head circle. Trace the outline of the muzzle, including the mouth. Add a tiny nostril.

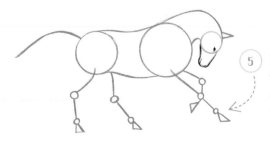

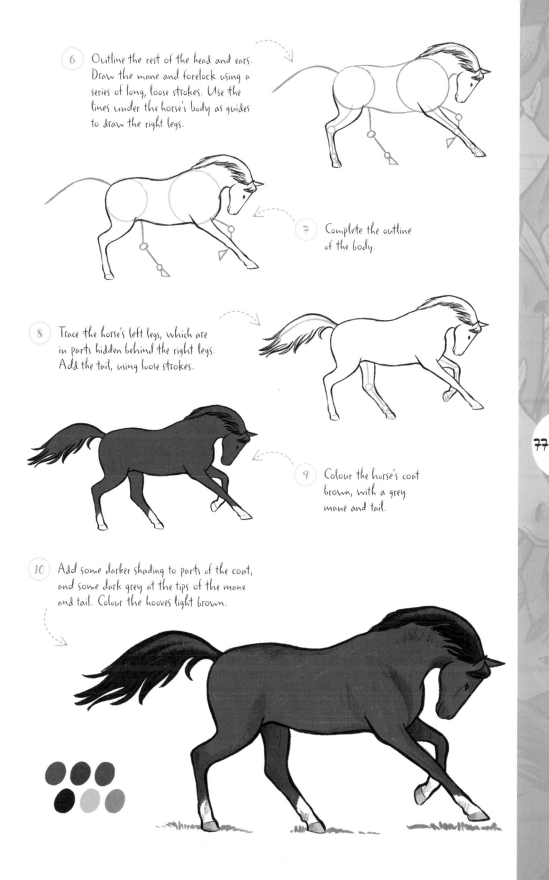

6. Outline the rest of the head and ears. Draw the mane and forelock using a series of long, loose strokes. Use the lines under the horse's body as guides to draw the right legs.

7. Complete the outline of the body.

8. Trace the horse's left legs, which are in parts hidden behind the right legs. Add the tail, using loose strokes.

9. Colour the horse's coat brown, with a grey mane and tail.

10. Add some darker shading to parts of the coat, and some dark grey at the tips of the mane and tail. Colour the hooves light brown.

Icelandic

This small, hardy horse from Iceland has a broad,
muscular neck with short, strong legs.

1 Draw two circles for the horse's
 head and muzzle. Connect the
 circles with two straight lines.

2 Add a circle to the right side, which
 will become the horse's chest. Draw
 two small triangles for the ears.

3 Create a U-shape to the
 right side of the chest
 circle for the horse's back.

4 Add guidelines for the legs, including
 triangles for the hooves. Note how the
 front legs are slightly apart, whereas the
 back legs are close together.

5 Draw the eye towards the bottom-right of
 the head circle. Add two curves for the nostrils,
 and draw the forelock between the ears.

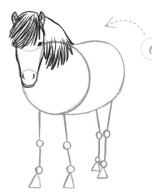

6 Outline the rest of the face, the ears and the mane along the neck.

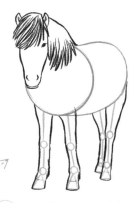

7 Use the guidelines to trace the outlines of the legs.

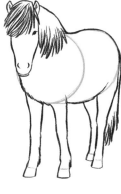

8 Complete the outline of the body, and add the tail behind the hind legs.

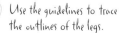

9 Colour the horse's coat brown, with a light brown above the hooves and around the nostrils.

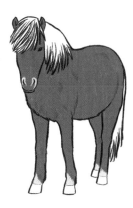

10 Colour the mane light brown, the muzzle and hooves dark grey, and add some darker shading to parts of the coat.

Friesian

The handsome Friesian from the Netherlands is strong and elegant, with a thick mane and tail, and long hair called feathers above the hooves.

1. Draw two circles for the horse's body of almost-equal size. Add a third circle to the left for the head.

2. Connect the circles with curved lines to form the neck and the body. Add a U-shape for the nose.

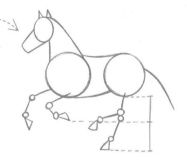

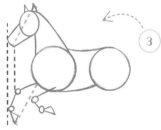

3. Add two triangles on top of the head for ears. Draw guidelines for the horse's front legs, with triangles for the hooves.

4. Add guidelines for the hind legs. Note how the horse's left hind leg is raised. Draw a tail guide to the right.

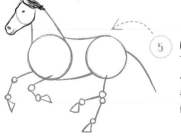

5. Use the head circle to position the eye. Trace the outline of the muzzle, including the mouth. Add the nostril. Then add the forelock. Note the direction of the wavy lines to indicate movement.

6 Outline the rest of the head. Draw the wild mane using long, wavy lines. As the horse is cantering, its mane will be moving to the right.

7 Use the guidelines to trace the outline of the front legs, adding some long hair above the hooves.

8 Continue with the hind legs.

9 Complete the outline of the body, and add the tail with long, wavy lines.

10 Colour the horse's coat dark grey, with a darker tone for the mane and tail, and lighter-coloured hooves.

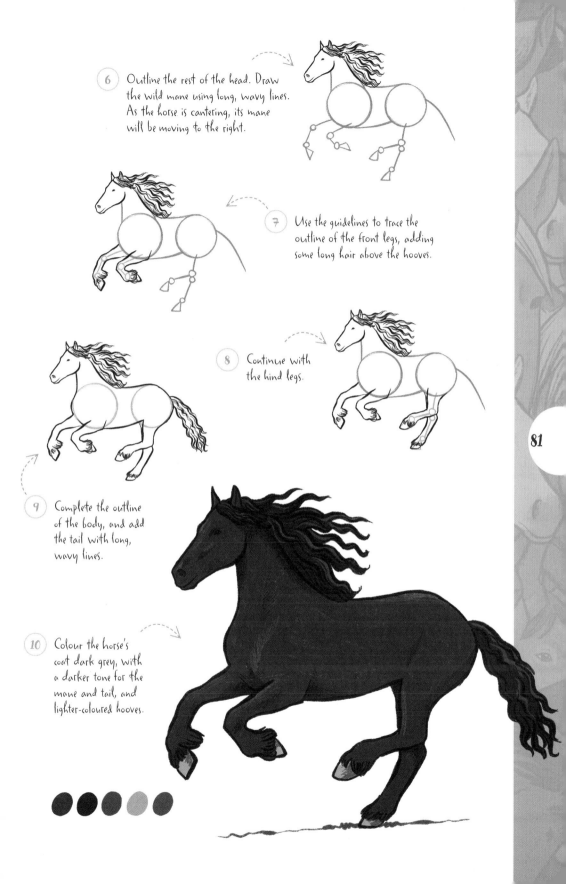

Gelderland

The Gelderland, from the Netherlands, is often used in carriage racing.
It usually has a chestnut (reddish-brown) coat with white markings.

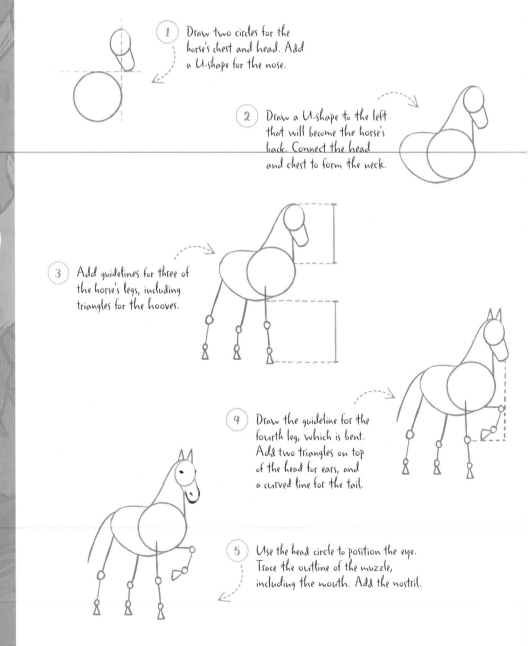

1. Draw two circles for the horse's chest and head. Add a U-shape for the nose.

2. Draw a U-shape to the left that will become the horse's back. Connect the head and chest to form the neck.

3. Add guidelines for three of the horse's legs, including triangles for the hooves.

4. Draw the guideline for the fourth leg, which is bent. Add two triangles on top of the head for ears, and a curved line for the tail.

5. Use the head circle to position the eye. Trace the outline of the muzzle, including the mouth. Add the nostril.

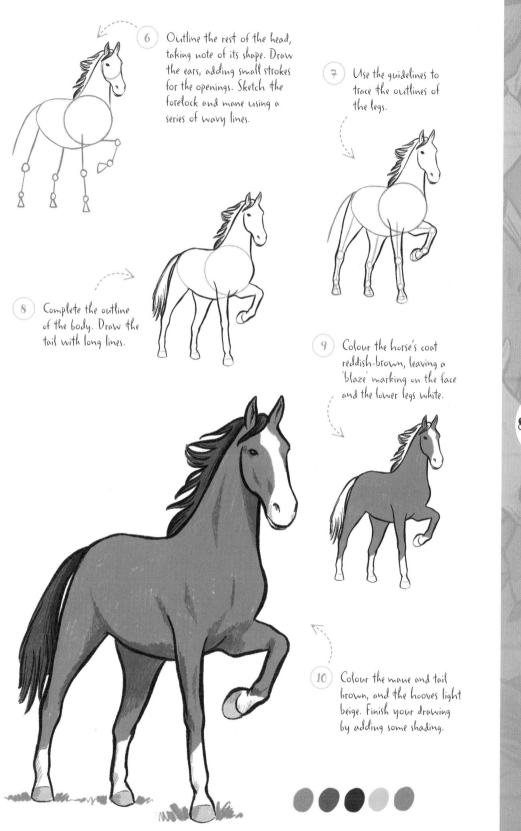

6 Outline the rest of the head, taking note of its shape. Draw the ears, adding small strokes for the openings. Sketch the forelock and mane using a series of wavy lines.

7 Use the guidelines to trace the outlines of the legs.

8 Complete the outline of the body. Draw the tail with long lines.

9 Colour the horse's coat reddish-brown, leaving a 'blaze' marking on the face and the lower legs white.

10 Colour the mane and tail brown, and the hooves light beige. Finish your drawing by adding some shading.

Fjord

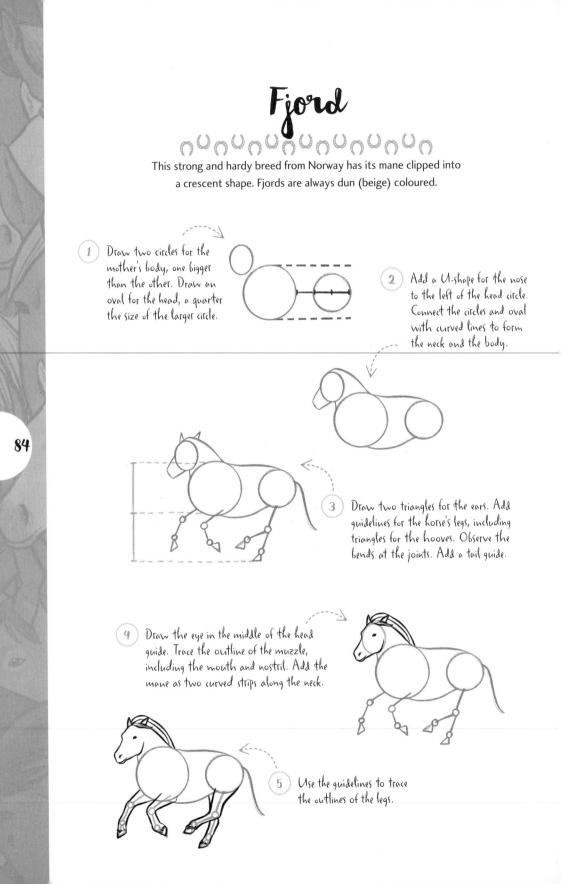

This strong and hardy breed from Norway has its mane clipped into a crescent shape. Fjords are always dun (beige) coloured.

1. Draw two circles for the mother's body, one bigger than the other. Draw an oval for the head, a quarter the size of the larger circle.

2. Add a U-shape for the nose to the left of the head circle. Connect the circles and oval with curved lines to form the neck and the body.

3. Draw two triangles for the ears. Add guidelines for the horse's legs, including triangles for the hooves. Observe the bends at the joints. Add a tail guide.

4. Draw the eye in the middle of the head guide. Trace the outline of the muzzle, including the mouth and nostril. Add the mane as two curved strips along the neck.

5. Use the guidelines to trace the outlines of the legs.

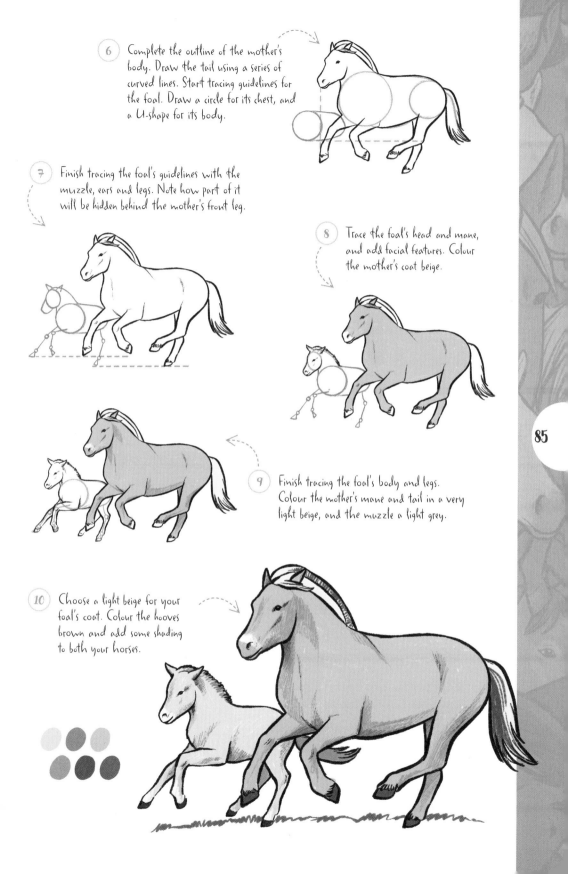

6 Complete the outline of the mother's body. Draw the tail using a series of curved lines. Start tracing guidelines for the foal. Draw a circle for its chest, and a U-shape for its body.

7 Finish tracing the foal's guidelines with the muzzle, ears and legs. Note how part of it will be hidden behind the mother's front leg.

8 Trace the foal's head and mane, and add facial features. Colour the mother's coat beige.

9 Finish tracing the foal's body and legs. Colour the mother's mane and tail in a very light beige, and the muzzle a light grey.

10 Choose a light beige for your foal's coat. Colour the hooves brown and add some shading to both your horses.

Dartmoor Pony

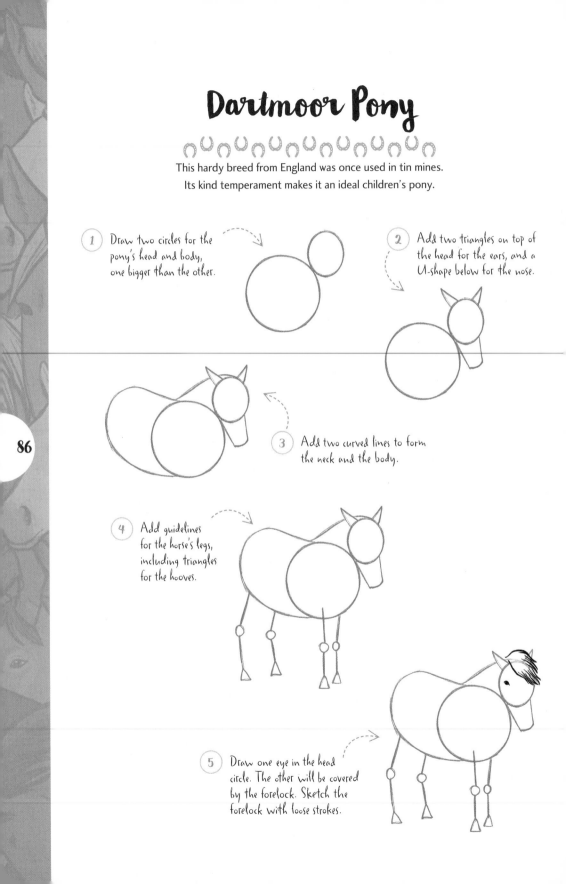

This hardy breed from England was once used in tin mines.
Its kind temperament makes it an ideal children's pony.

1 Draw two circles for the pony's head and body, one bigger than the other.

2 Add two triangles on top of the head for the ears, and a U-shape below for the nose.

3 Add two curved lines to form the neck and the body.

4 Add guidelines for the horse's legs, including triangles for the hooves.

5 Draw one eye in the head circle. The other will be covered by the forelock. Sketch the forelock with loose strokes.

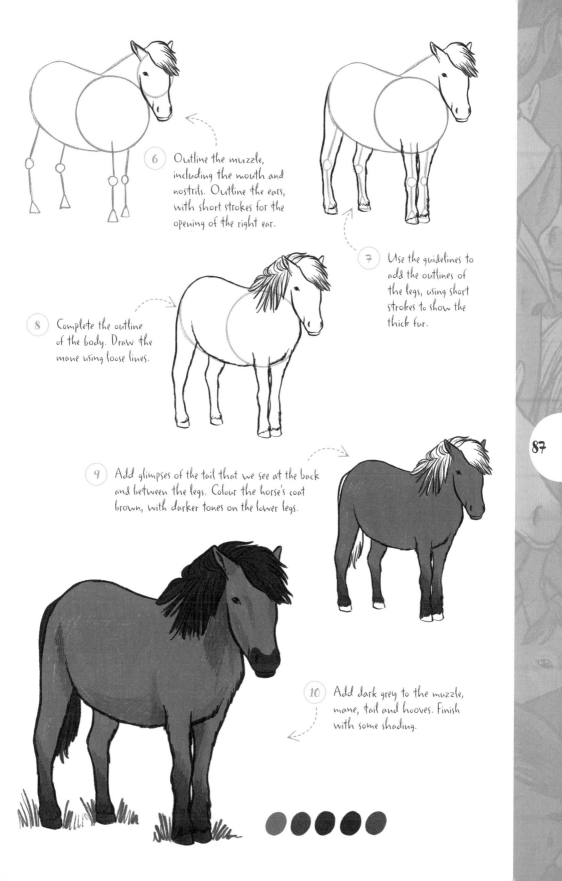

6 Outline the muzzle, including the mouth and nostrils. Outline the ears, with short strokes for the opening of the right ear.

7 Use the guidelines to add the outlines of the legs, using short strokes to show the thick fur.

8 Complete the outline of the body. Draw the mane using loose lines.

9 Add glimpses of the tail that we see at the back and between the legs. Colour the horse's coat brown, with darker tones on the lower legs.

10 Add dark grey to the muzzle, mane, tail and hooves. Finish with some shading.

Clydesdale

The Clydesdale is a draught horse from Scotland. Usually bay (brown) in colour with white legs, note the feathers (long hair) above their hooves.

1. Draw two circles for the body, one slightly bigger than the other.

2. Add guidelines for the legs, including triangles for the hooves.

3. Draw another circle for the head, a quarter the size of the larger circle. Add a triangle for the ear, and a U-shape for the nose below.

4. Connect the circles with curved lines to form the neck and the body. Add a curved line for the tail.

5. Draw one eye in the head circle. Darken the outline of the head, including the mouth. Add the nostril.

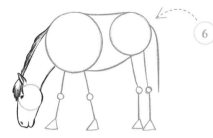

6 Define the ear outlines, using small strokes for the openings. Draw the forelock and mane using a series of straight lines.

7 Use the guidelines to trace the outlines of the legs, using short strokes to show the long hair above the hooves.

8 Finish outlining the body. Draw the tail using a series of straight lines.

9 Colour the horse's coat in brown, leaving a 'blaze' marking on the face and the legs white. Add some grey to the muzzle.

10 Add a dark-brown mane and tail. Finish your drawing with some shading.

Andalusian

An elegant and athletic breed, also known as the Pure Spanish Horse,
Andalusians excel at dressage, as well as showjumping.

1. Draw a circle for the chest. Add another circle for the head that is a quarter the size of the first circle. Draw a horizontal U-shape to the left for the back.

2. Add two triangles on top of the head for ears, and a U-shape for the nose.

3. Connect the circles with curved lines to form the neck and the body. Add guidelines for the horse's right legs.

4. Draw the remaining two legs of the horse. Add a curved line as a tail guide.

5. Use the head circle to position the eyes, one of which is only just visible. Trace the outline of the head, including the muzzle and mouth. Add two nostrils, one on the very edge of the muzzle. Trace the ears, with some shading in the openings. Add a long forelock.

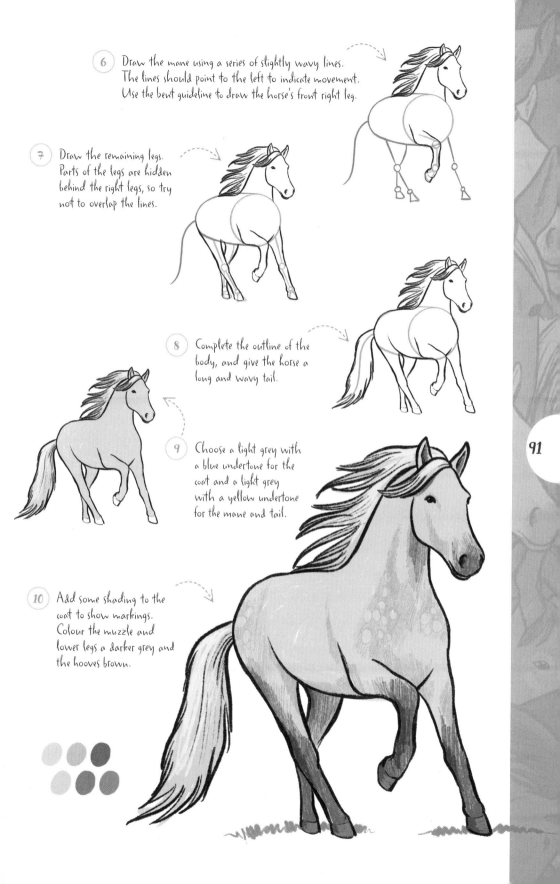

6 Draw the mane using a series of slightly wavy lines. The lines should point to the left to indicate movement. Use the bent guideline to draw the horse's front right leg.

7 Draw the remaining legs. Parts of the legs are hidden behind the right legs, so try not to overlap the lines.

8 Complete the outline of the body, and give the horse a long and wavy tail.

9 Choose a light grey with a blue undertone for the coat and a light grey with a yellow undertone for the mane and tail.

10 Add some shading to the coat to show markings. Colour the muzzle and lower legs a darker grey and the hooves brown.

Dutch Warmblood

A competition horse that is bred to perform at the highest levels in sport, the Dutch Warmblood excels in dressage and showjumping.

1. Draw two circles for the body, one slightly bigger than the other. Connect the circles with curved lines. Draw another circle for the head, a quarter the size of the larger circle.

2. Add two triangles for the ears, and a U-shape for the nose. Connect the head to the body with curved lines. Add a tail guide.

3. Add guidelines for the legs, including triangles for the hooves. Note how the joints are bending, and their length in relation to the body.

4. Use the head circle to position the eye. Trace the outline of the muzzle, including the mouth. Add the nostril.

5. Outline the rest of the head. Draw the ears, adding small strokes for the openings. Sketch the forelock, using curved lines.

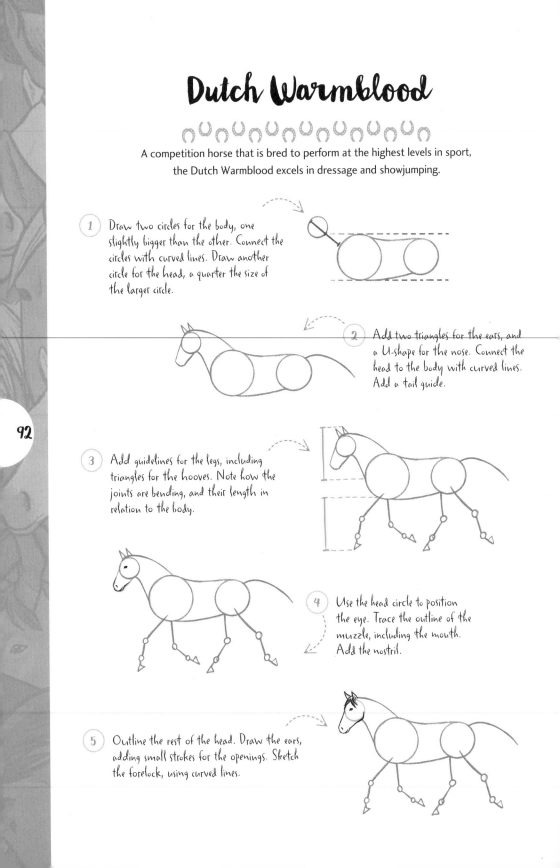

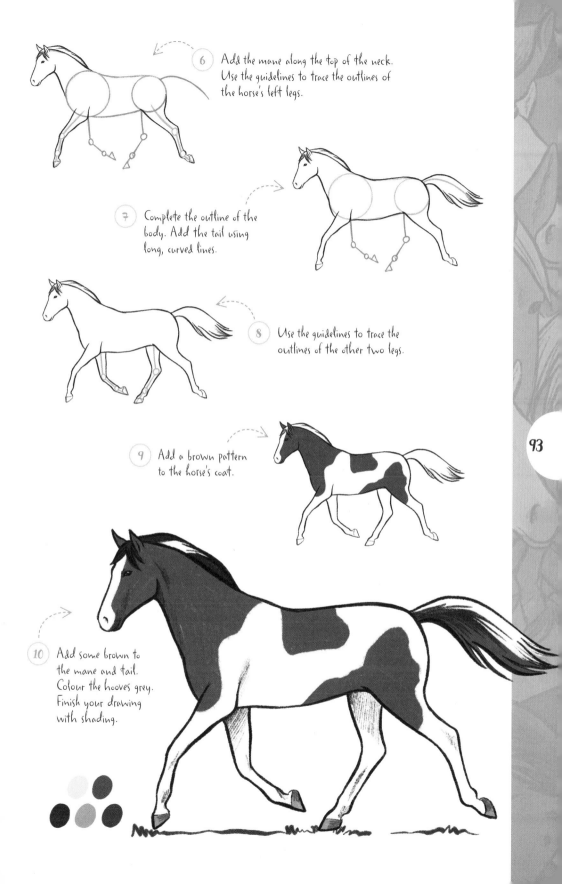

6 Add the mane along the top of the neck. Use the guidelines to trace the outlines of the horse's left legs.

7 Complete the outline of the body. Add the tail using long, curved lines.

8 Use the guidelines to trace the outlines of the other two legs.

9 Add a brown pattern to the horse's coat.

10 Add some brown to the mane and tail. Colour the hooves grey. Finish your drawing with shading.

Lipizzaner

Most famous as the horse used by the Spanish Riding School of Vienna, Lipizzaners almost always have white coats.

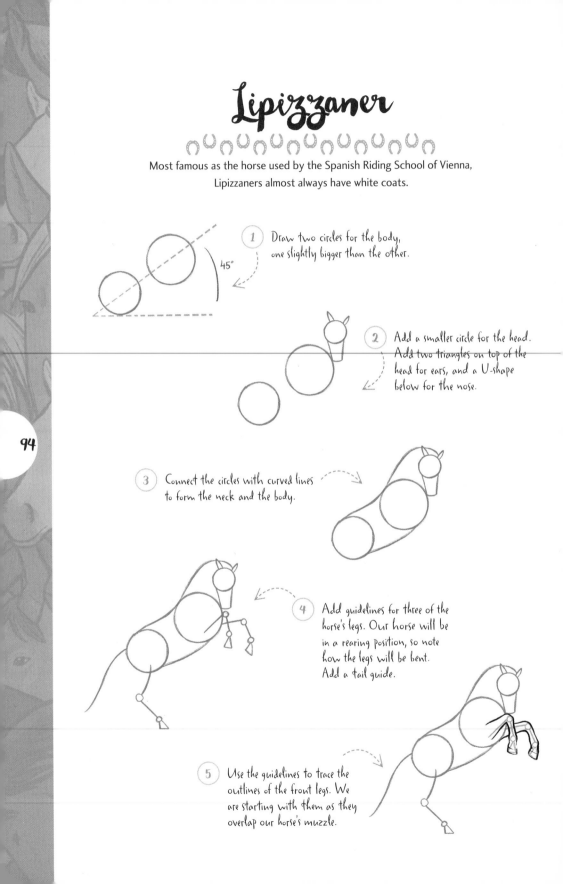

1. Draw two circles for the body, one slightly bigger than the other.

45°

2. Add a smaller circle for the head. Add two triangles on top of the head for ears, and a U-shape below for the nose.

3. Connect the circles with curved lines to form the neck and the body.

4. Add guidelines for three of the horse's legs. Our horse will be in a rearing position, so note how the legs will be bent. Add a tail guide.

5. Use the guidelines to trace the outlines of the front legs. We are starting with them as they overlap our horse's muzzle.

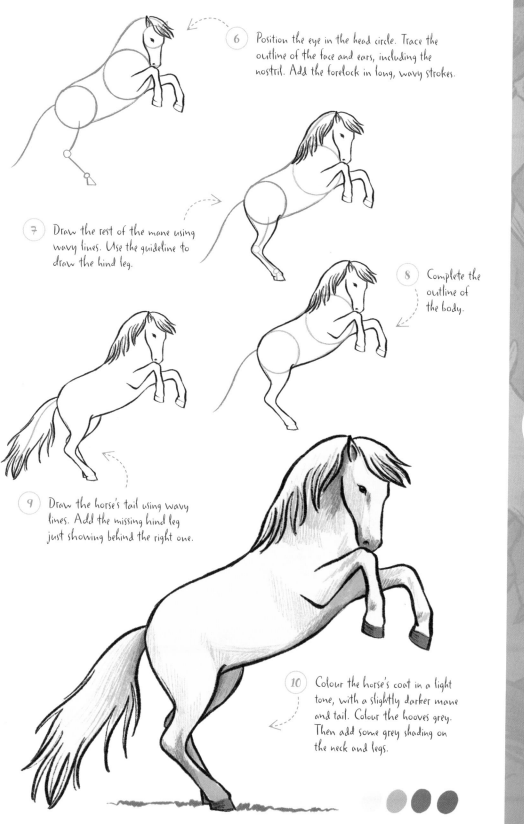

6 Position the eye in the head circle. Trace the outline of the face and ears, including the nostril. Add the forelock in long, wavy strokes.

7 Draw the rest of the mane using wavy lines. Use the guideline to draw the hind leg.

8 Complete the outline of the body.

9 Draw the horse's tail using wavy lines. Add the missing hind leg just showing behind the right one.

10 Colour the horse's coat in a light tone, with a slightly darker mane and tail. Colour the hooves grey. Then add some grey shading on the neck and legs.

Fell Pony

A moorland and mountain pony from north-west England, the Fell Pony is an intelligent breed and a popular choice for general riding.

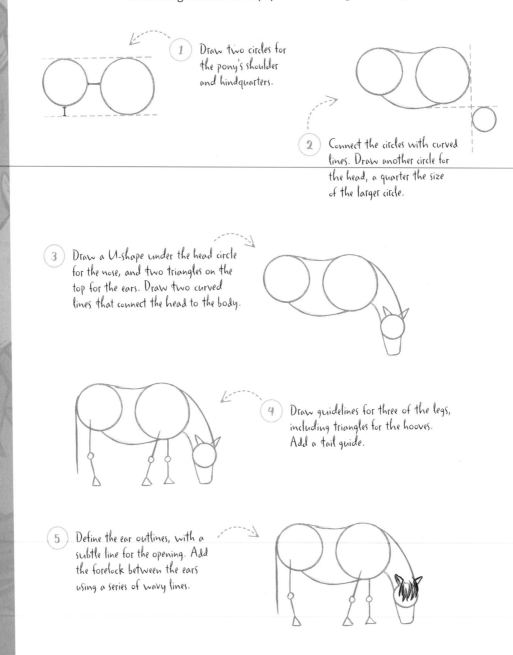

1. Draw two circles for the pony's shoulder and hindquarters.

2. Connect the circles with curved lines. Draw another circle for the head, a quarter the size of the larger circle.

3. Draw a U-shape under the head circle for the nose, and two triangles on the top for the ears. Draw two curved lines that connect the head to the body.

4. Draw guidelines for three of the legs, including triangles for the hooves. Add a tail guide.

5. Define the ear outlines, with a subtle line for the opening. Add the forelock between the ears using a series of wavy lines.

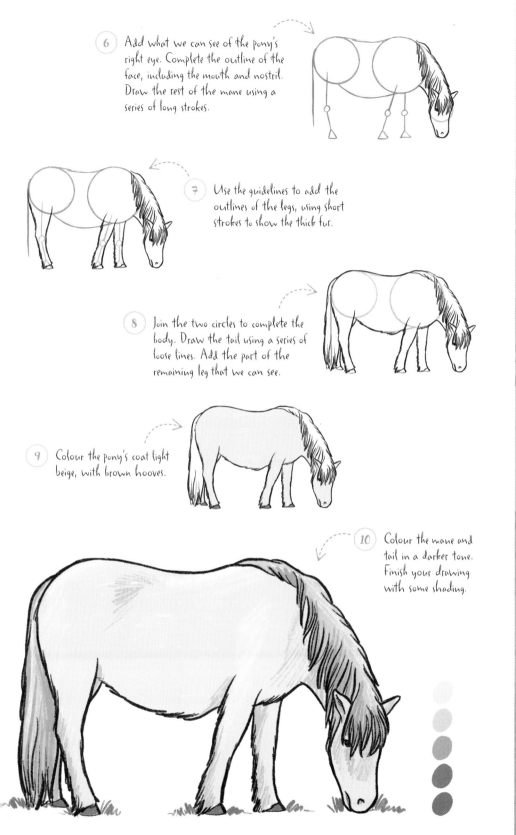

6 Add what we can see of the pony's right eye. Complete the outline of the face, including the mouth and nostril. Draw the rest of the mane using a series of long strokes.

7 Use the guidelines to add the outlines of the legs, using short strokes to show the thick fur.

8 Join the two circles to complete the body. Draw the tail using a series of loose lines. Add the part of the remaining leg that we can see.

9 Colour the pony's coat light beige, with brown hooves.

10 Colour the mane and tail in a darker tone. Finish your drawing with some shading.

Shetland Pony

This short, stocky pony from the Shetland Islands of Scotland has a thick mane and tail, with a dense coat in winter to survive the cold and wet.

1. Draw two circles for the body, one bigger than the other. Draw another circle for the head. Note their relative positions.

2. Add a U-shape below the head for the nose. Connect the circles with curved lines.

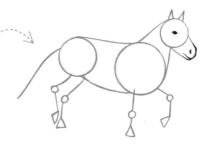

3. Draw two triangles on top of the head for the ears. Add guidelines for the horse's legs, including triangles for the hooves. Add a tail guide.

4. Draw the eye in the middle of the head circle. Trace the outline of the muzzle, including the mouth. Add the nostril, with a little shading for the opening.

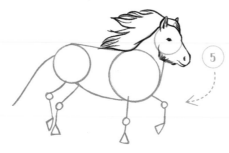

5. Outline the rest of the head, taking note of its shape. On the lower jaw, use a series of short strokes to show long hair. Draw the forelock and mane using a series of wavy lines. The direction of the lines suggest the pony's movement.

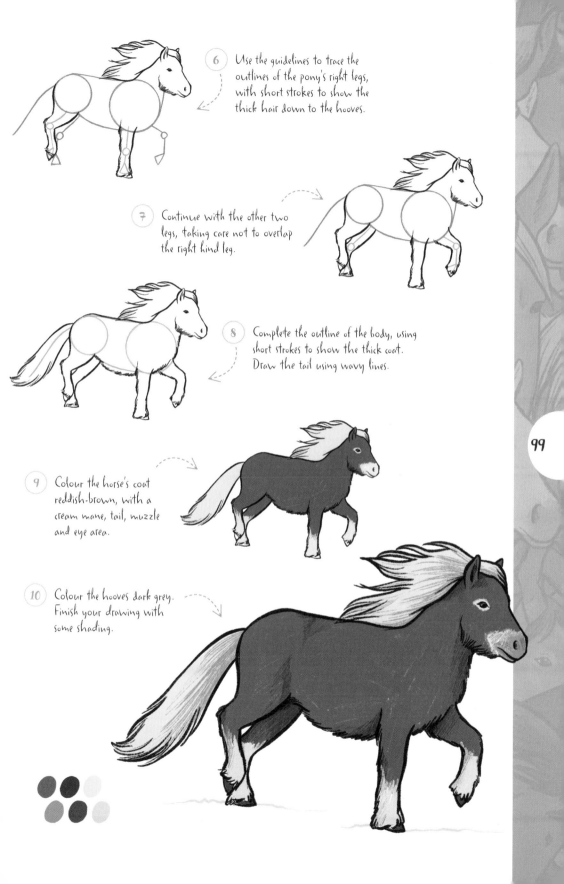

6. Use the guidelines to trace the outlines of the pony's right legs, with short strokes to show the thick hair down to the hooves.

7. Continue with the other two legs, taking care not to overlap the right hind leg.

8. Complete the outline of the body, using short strokes to show the thick coat. Draw the tail using wavy lines.

9. Colour the horse's coat reddish-brown, with a cream mane, tail, muzzle and eye area.

10. Colour the hooves dark grey. Finish your drawing with some shading.

Shire

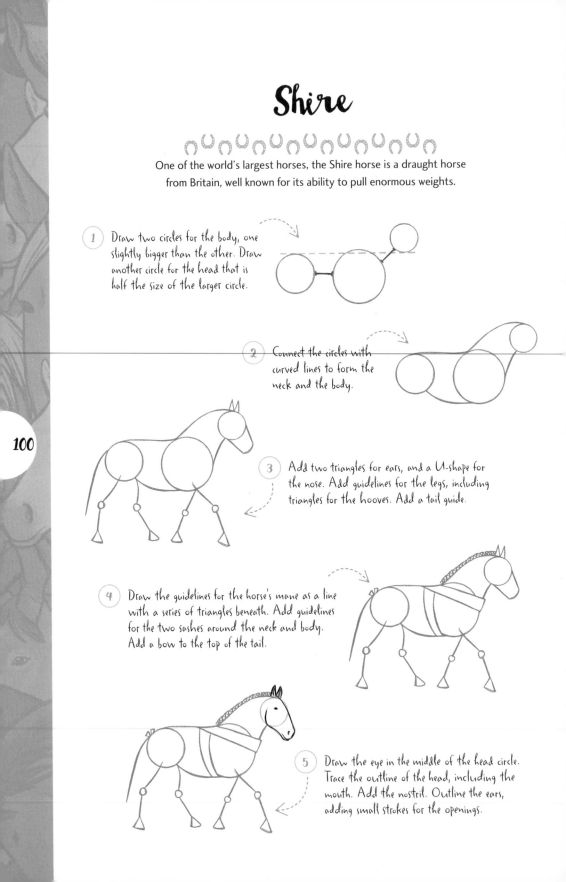

One of the world's largest horses, the Shire horse is a draught horse
from Britain, well known for its ability to pull enormous weights.

1 Draw two circles for the body, one
slightly bigger than the other. Draw
another circle for the head that is
half the size of the larger circle.

2 Connect the circles with
curved lines to form the
neck and the body.

3 Add two triangles for ears, and a U-shape for
the nose. Add guidelines for the legs, including
triangles for the hooves. Add a tail guide.

4 Draw the guidelines for the horse's mane as a line
with a series of triangles beneath. Add guidelines
for the two sashes around the neck and body.
Add a bow to the top of the tail.

5 Draw the eye in the middle of the head circle.
Trace the outline of the head, including the
mouth. Add the nostril. Outline the ears,
adding small strokes for the openings.

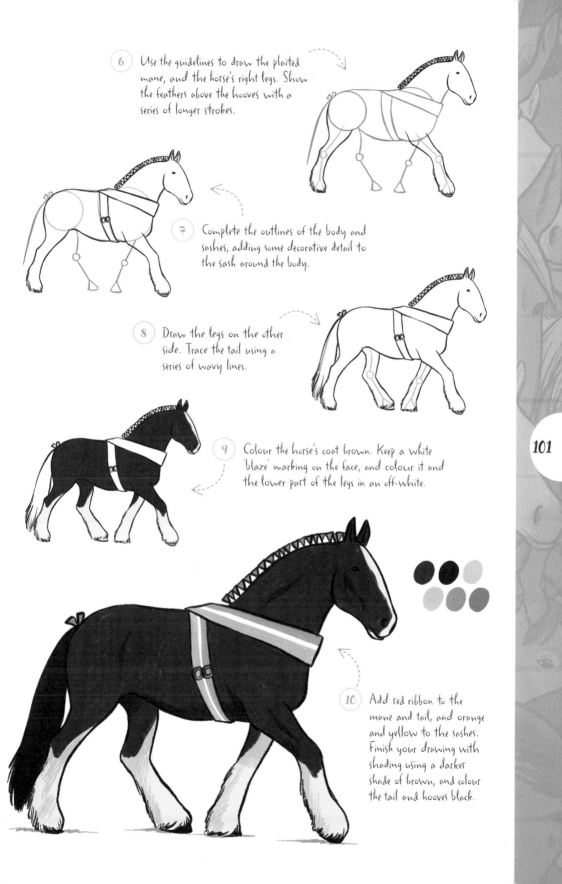

6 Use the guidelines to draw the plaited mane, and the horse's right legs. Show the feathers above the hooves with a series of longer strokes.

7 Complete the outlines of the body and sashes, adding some decorative detail to the sash around the body.

8 Draw the legs on the other side. Trace the tail using a series of wavy lines.

9 Colour the horse's coat brown. Keep a white 'blaze' marking on the face, and colour it and the lower part of the legs in an off-white.

10 Add red ribbon to the mane and tail, and orange and yellow to the sashes. Finish your drawing with shading using a darker shade of brown, and colour the tail and hooves black.

Suffolk Punch

This English draught horse has a powerful, arched neck for pulling huge weights. It is always chestnut (reddish-brown) in colour.

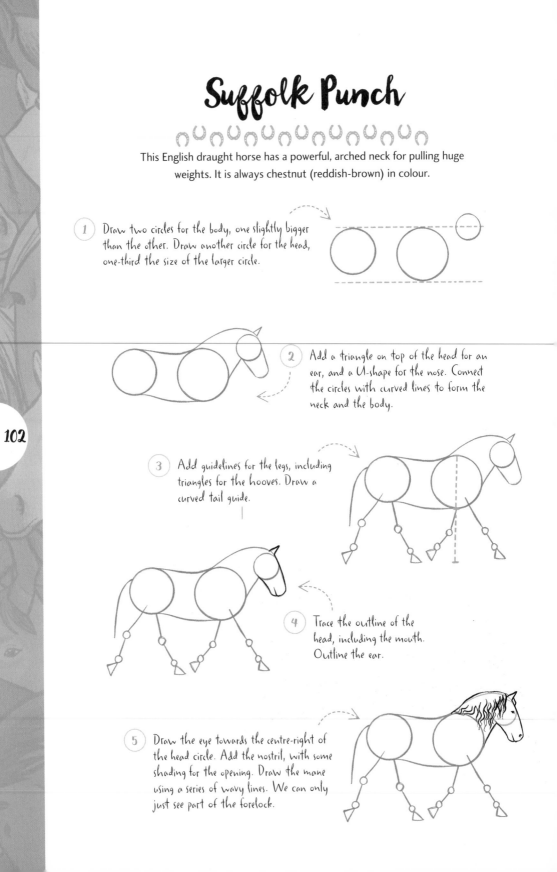

1. Draw two circles for the body, one slightly bigger than the other. Draw another circle for the head, one-third the size of the larger circle.

2. Add a triangle on top of the head for an ear, and a U-shape for the nose. Connect the circles with curved lines to form the neck and the body.

3. Add guidelines for the legs, including triangles for the hooves. Draw a curved tail guide.

4. Trace the outline of the head, including the mouth. Outline the ear.

5. Draw the eye towards the centre-right of the head circle. Add the nostril, with some shading for the opening. Draw the mane using a series of wavy lines. We can only just see part of the forelock.

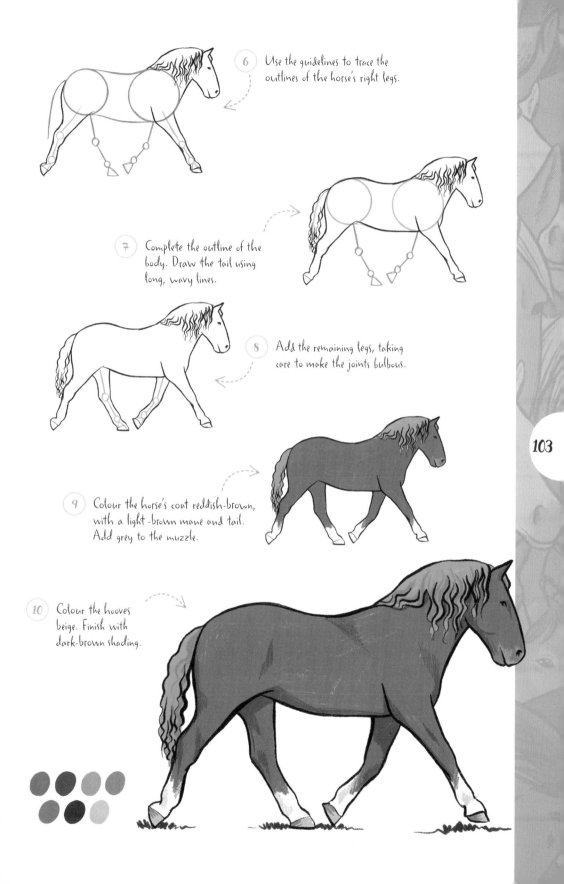

6 Use the guidelines to trace the outlines of the horse's right legs.

7 Complete the outline of the body. Draw the tail using long, wavy lines.

8 Add the remaining legs, taking care to make the joints bulbous.

9 Colour the horse's coat reddish-brown, with a light-brown mane and tail. Add grey to the muzzle.

10 Colour the hooves beige. Finish with dark-brown shading.

Welsh Pony

The spirited Welsh Pony has a relatively small head and short back, and carries its tail high. Its face is often dish-shaped in profile due to influence from Arab breeds, with which it is often cross-bred.

1. Draw two circles for the body, one slightly bigger than the other. Draw another circle for the head, about one-third the size of the larger circle.

2. Add a U-shape for the nose. Connect the circles with curved lines to form the neck and the body.

3. Draw two triangles for the ears. Add guidelines for the horse's right legs, including triangles for the hooves. Draw a tail guide.

4. Add guidelines for the remaining two legs. Observe the bends at the joints.

5. Draw the eye towards the top of the head circle. Trace the outline of the head, including the mouth. Add the nostril.

6 Outline the ears, adding a fine line for one opening. Add the forelock and mane using loose, curved lines.

7 Use the guidelines to trace the outlines of the horse's right legs.

8 Continue with the other legs, taking care where the two legs overlap. Finish the outline of the body. Draw the tail.

9 Colour the horse's coat light brown, leaving a 'blaze' marking on the face and the lower legs white. Add grey to the upper legs and muzzle.

10 Colour the hooves light brown, and use black for the mane and tail. Finish with some darker shading.

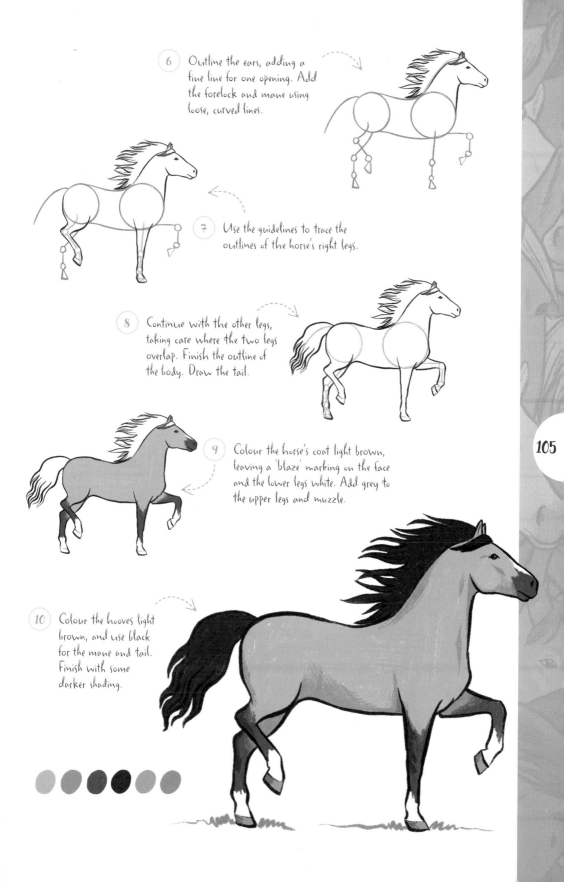

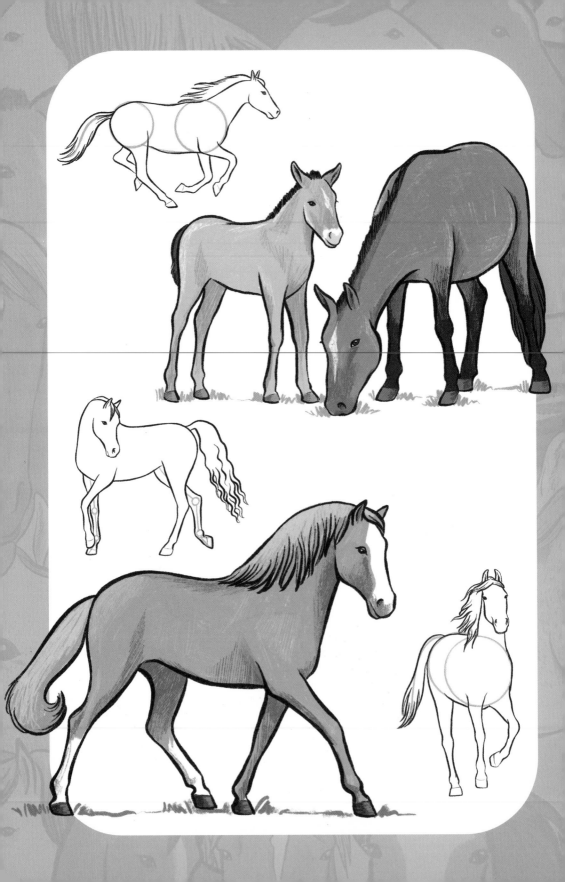

From Africa, Asia & Australia

Barb

The Barb is a horse of speed and endurance from North Africa, used historically for racing, but also for dressage.

1. Draw two circles for the body, one slightly bigger than the other. Draw an oval for the head, approximately one-third the size of the largest circle.

2. Add two triangles for the ears, and a U-shape for the nose. Connect the circles and oval with curved lines.

3. Add guidelines for the horse's right legs, including triangles for the hooves. Note their length in relation to the body.

4. Add guidelines for the remaining legs, and a curved tail guide.

5. Draw the eye in the middle of the oval. Trace the outline of the head, including the mouth and nostril.

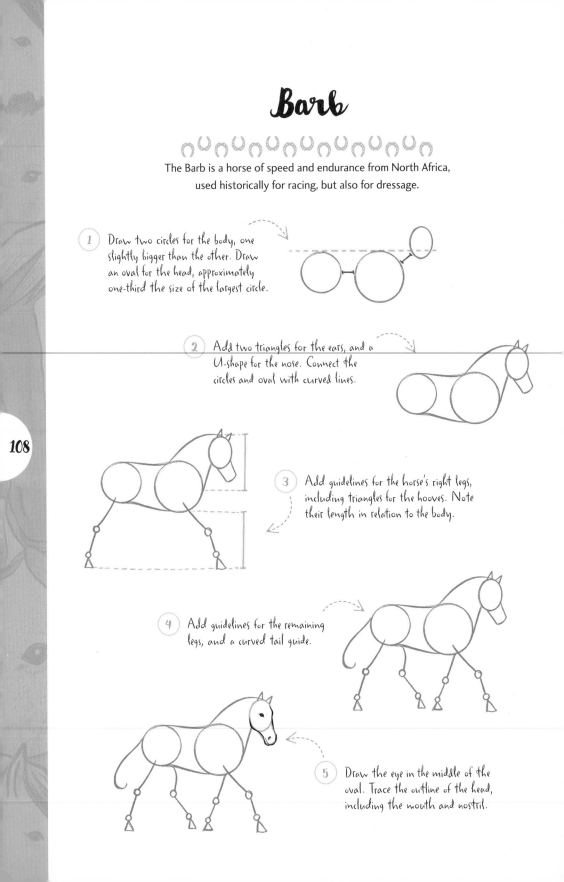

6 Outline the ears, adding a short stroke for the opening. Draw the forelock and mane using a series of loose, curved lines.

7 Use the guidelines to trace the outlines of the horse's right legs.

8 Complete the outline of the body.

9 Draw the remaining two legs. Add the tail using a series of short strokes on the edges and end.

10 Colour the coat light brown, with a beige mane and tail. Leave a 'blaze' marking on its face and the 'socks' on its hind legs white. Add grey to the muzzle and hooves. Finish with some shading.

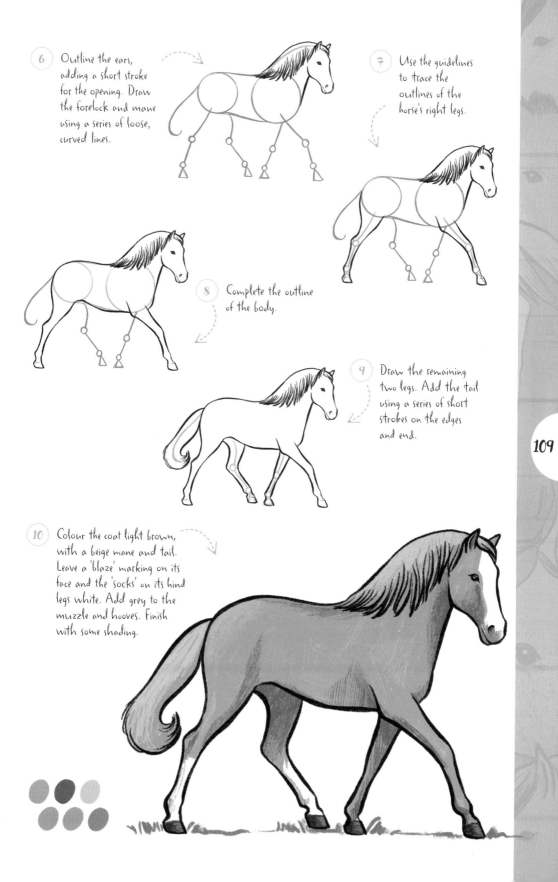

Arab

Arabs are one of the most popular horse breeds in the world, with their distinctive, dish-shaped head profile and high tail carriages.

1. Draw an oval for the head. Add two triangles for ears, and a U-shaped nose.

2. Draw a circle around the nose for the chest. Add a second, smaller circle to the right for the hindquarters.

3. Connect the circles and oval with curved lines to form the neck and the body.

4. Add guidelines for the horse's right legs, including triangles for the hooves.

5. Add the guidelines for the remaining two legs. Note the bends a the joints. Sketch a long, curved guideline for the tail.

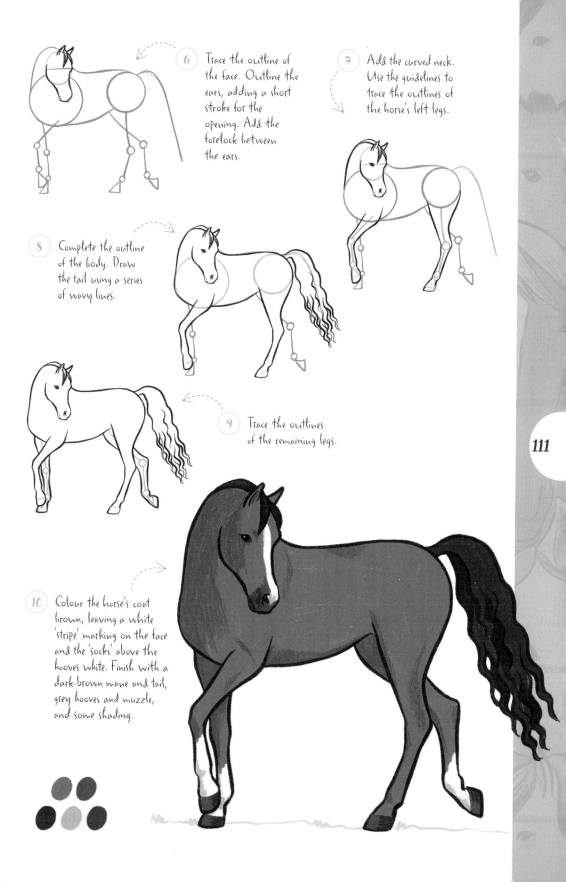

6 Trace the outline of the face. Outline the ears, adding a short stroke for the opening. Add the forelock between the ears.

7 Add the curved neck. Use the guidelines to trace the outlines of the horse's left legs.

8 Complete the outline of the body. Draw the tail using a series of wavy lines.

9 Trace the outlines of the remaining legs.

111

10 Colour the horse's coat brown, leaving a white 'stripe' marking on the face and the 'socks' above the hooves white. Finish with a dark-brown mane and tail, grey hooves and muzzle, and some shading.

Kathiawari

This desert horse from western India has distinctive, inward-curving ears, which may touch or even overlap.

1. Draw a circle for the forehead. Add a U-shape below for the nose.

2. Add a large circle below for the chest. Add two lines above to form the horse's neck.

3. Draw two triangles on top of the head for the ears. Create an arc on the left to create the horse's back. Add a curved tail guide.

4. Add guidelines for three of the horse's legs, including triangles for the hooves.

5. Draw the eyes on the edges of the head circle. Trace the outline of the muzzle, including the mouth and nostrils.

6 Outline the rest of the face. Draw the inward-curving ears, with short strokes for the openings. Add the forelock between the ears, using a series of curved strokes.

7 Draw the mane flowing to one side of the neck. Use the guidelines to trace the outlines of the legs.

8 Complete the outline of the body. Draw the tail using a series of wavy lines.

9 Add the fourth leg, partially hidden behind the front leg. Colour the coat brown, leaving a white 'blaze' marking white. Add a dark-brown mane and tail.

10 Add some shading to the horse's body. Colour the hooves in a beige shade, and darken the lower legs.

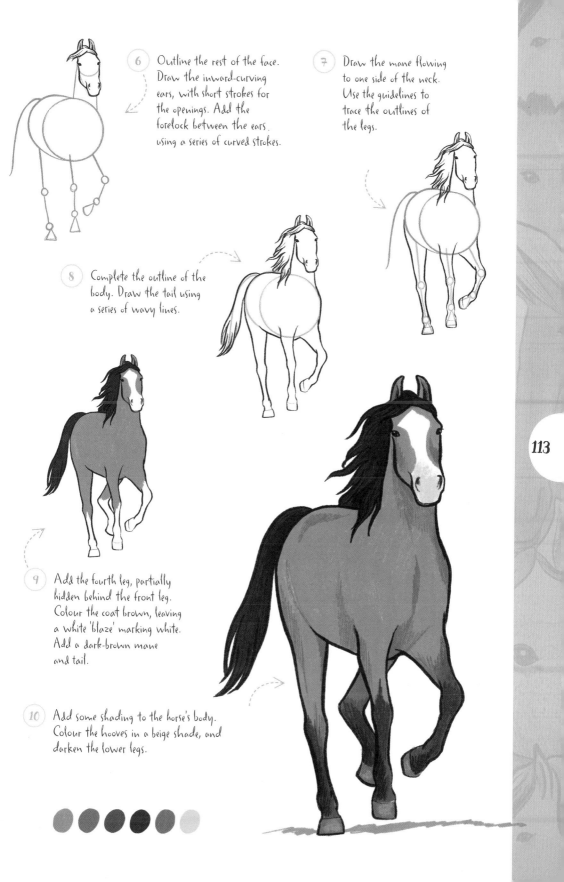

Marwari

This rare breed of horse from Rajasthan, in India, is a close relative of the Kathiawari, and you can see why with its inward-curving ears.

① Draw two circles for the body, one slightly bigger than the other. Draw an oval for the head, approximately quarter the size of the largest circle.

② Connect the oval and circles with curved lines. Add two inward-curving triangles for the ears, and a U-shape for the nose.

114

③ Add guidelines for the horse's left legs, including triangles for the hooves.

④ Create guidelines for the remaining two legs. Add a guideline for the tail.

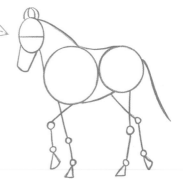

⑤ Draw the eyes towards the edges of the head guide. Trace the outline of the muzzle, including the mouth and nostrils.

6 Outline the rest of the head. Draw the ears, noting how they curve inwards to touch. Draw the forelock and mane using a series of slightly wavy lines.

7 Use the guidelines to trace the outlines of the horse's left legs. The tops of the legs should be thicker.

8 Outline the rest of the body. Trace the outlines of the remaining legs. Sketch the tail using a series of curved lines.

9 Colour the horse's coat dark brown, leaving a white 'blaze' on the face.

10 Add a darker-brown mane and tail, and light-brown hooves. Finish your drawing with shading.

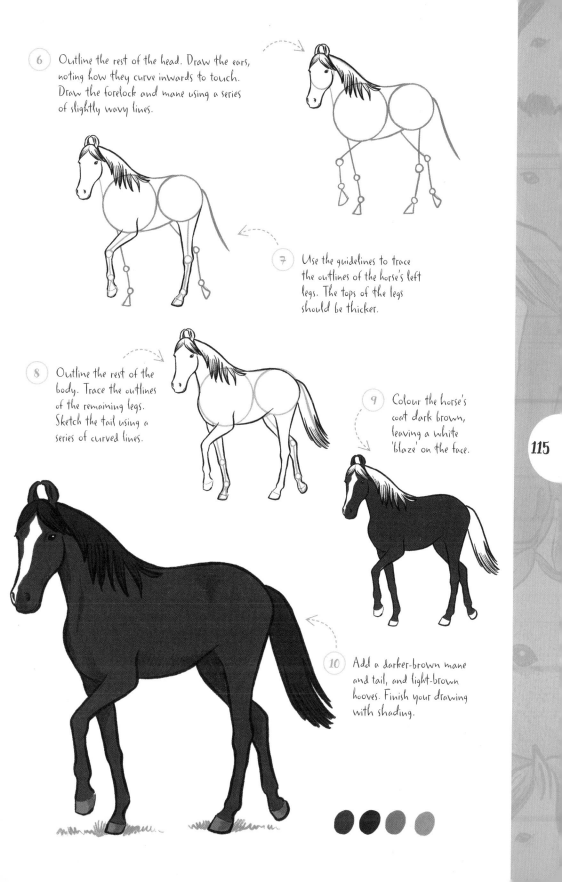

Akhal-Teke

The graceful Akhal-Teke is from Turkmenistan. It has a distinctive, shiny coat, and a thin mane that is often shaved.

1. Starting with the foal, draw two circles for the body, one slightly bigger than the other. Draw an oval for the head, approximately a quarter the size of the largest circle.

2. Now draw a circle for the mother's chest. Note how it interacts with the foal's back circle.

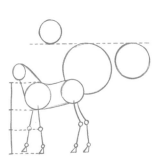

3. Add a small circle to the left for the mother's head and a circle to the right for the hindquarters. Add guidelines for the foal's legs, including triangles for the hooves.

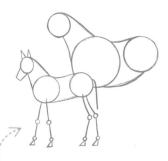

4. Add two triangles on top of the foal's head for ears, and a U-shape for the nose. Draw a line to the right for the tail guide. Connect the circles for the mother's body.

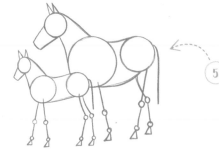

5. Repeat these steps for the mother, adding guidelines for the ears, muzzle, legs and tail.

6 Use the head circles to position the eyes. Trace the outline of the muzzles, including the mother's mouth. Add the nostrils.

7 Draw the ears, adding small strokes for the openings. Use the guidelines to trace the outlines of the legs. Part of the legs are hidden behind the left legs.

8 Complete the outline of the foal's body. Add the fluffy mane and tail.

9 Complete the outline of the mother's body, and add the tail. Note the lack of a mane on the mother as it has been shaved.

10 Colour the foal in light brown, and the mother in a darker brown, leaving a white 'star' marking on both foreheads. Add some grey to both muzzles, and darker shading to the legs. Colour the hooves light brown and finish with some shading.

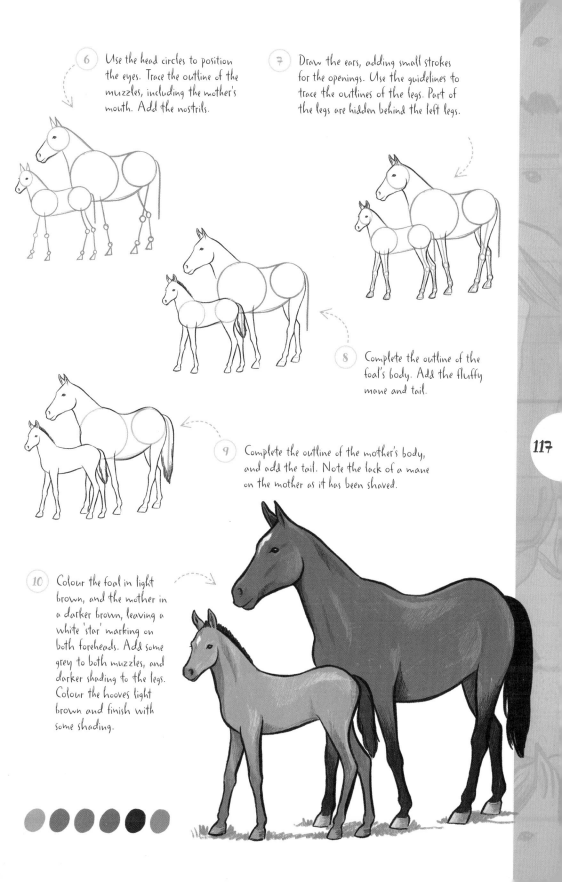

Don Horse

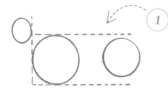

Named after the River Don, in southern Russia, the Don horse was ridden by the Cossack cavalry. Usually a reddish-brown colour, it can be black, brown, or white.

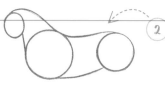

1 Draw two circles for the horse's body, one slightly bigger than the other. Draw another circle for the head, one-fifth the size of the larger circle.

2 Connect the circles with curved lines to form the neck and the body.

3 Add a U-shape beneath the head for the nose, and two triangles for the ears. Sketch guidelines for three of the horse's legs, with triangles for hooves. Draw a long, curved tail guide.

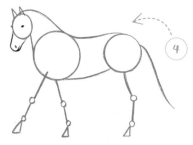

4 Draw one eye in the middle of the head circle, and a little line on the left edge of the circle for the other eye. Trace the outline of the muzzle, including the mouth. Add the nostril.

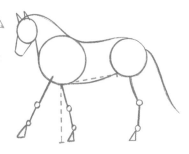

5 Outline the rest of the face. Draw the ears, adding small strokes for the openings. Add the forelock and mane using a series of curved lines.

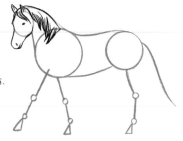

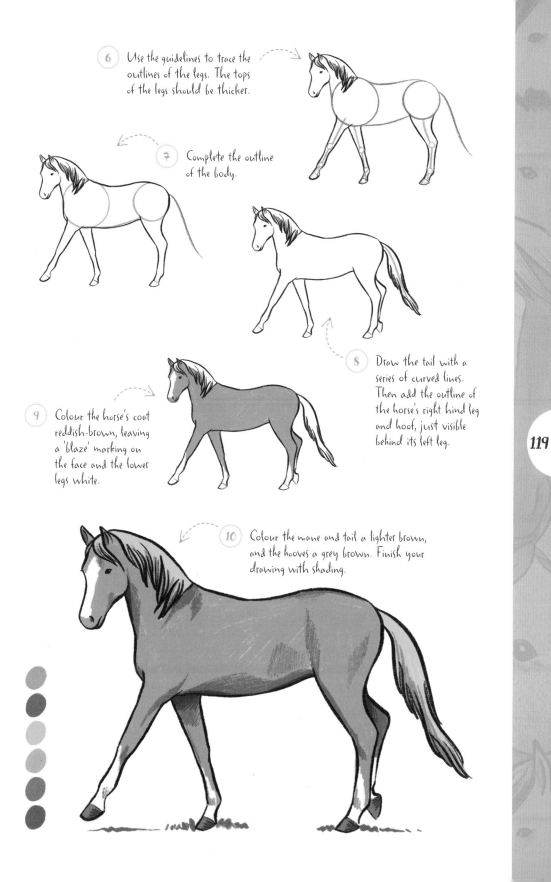

6 Use the guidelines to trace the outlines of the legs. The tops of the legs should be thicker.

7 Complete the outline of the body.

8 Draw the tail with a series of curved lines. Then add the outline of the horse's right hind leg and hoof, just visible behind its left leg.

9 Colour the horse's coat reddish-brown, leaving a 'blaze' marking on the face and the lower legs white.

10 Colour the mane and tail a lighter brown, and the hooves a grey brown. Finish your drawing with shading.

Orlov Trotter

Named after its fast trot, and the 18th-century breeder Count Orlov, the Orlov Trotter is Russia's most well-known breed.

1. Draw two circles for the horse's body, one bigger than the other. Draw another circle for the head, one-third the size of the larger circle. Observe the positioning of each circle.

2. Connect the circles with curved lines to form the neck and the body. Add a U-shape beneath the head for the nose.

3. Add guidelines for the horse's right legs. Draw a triangle on top of the head for an ear. Add an S-shaped tail guide.

4. Draw the eye to the lower-right of the head circle. Trace the outline of the muzzle, including the mouth. Add the nostril.

5. Outline the rest of the head and ears. Draw the forelock and mane using a series of slightly wavy lines. The lines should point to the left to indicate movement.

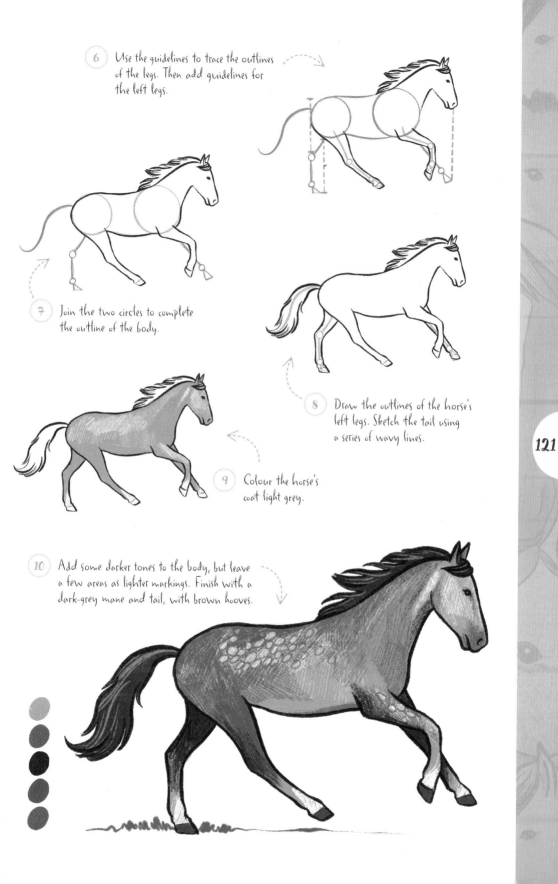

6 Use the guidelines to trace the outlines of the legs. Then add guidelines for the left legs.

7 Join the two circles to complete the outline of the body.

8 Draw the outlines of the horse's left legs. Sketch the tail using a series of wavy lines.

9 Colour the horse's coat light grey.

10 Add some darker tones to the body, but leave a few areas as lighter markings. Finish with a dark-grey mane and tail, with brown hooves.

Yakutian

This small, stout horse from Siberia has an extremely thick coat
to survive temperatures as low as −70°C (−94°F).

1. Draw two circles for the horse's body, one bigger than the other. Draw another circle for the head, a quarter the size of the larger circle. Add a U-shaped nose below.

2. Connect the circles with curved lines. Note the round line for the tummy.

3. Add guidelines for the horse's legs, including triangles for the hooves.

4. Draw two triangles for the ears. Add a tail guide to the left.

5. Draw two eyes towards the outer edges of the head circle. Trace the outline of nostrils and lips.

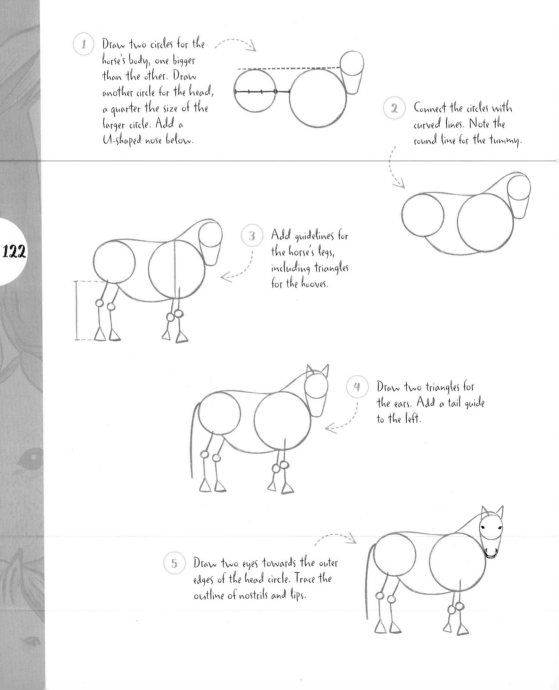

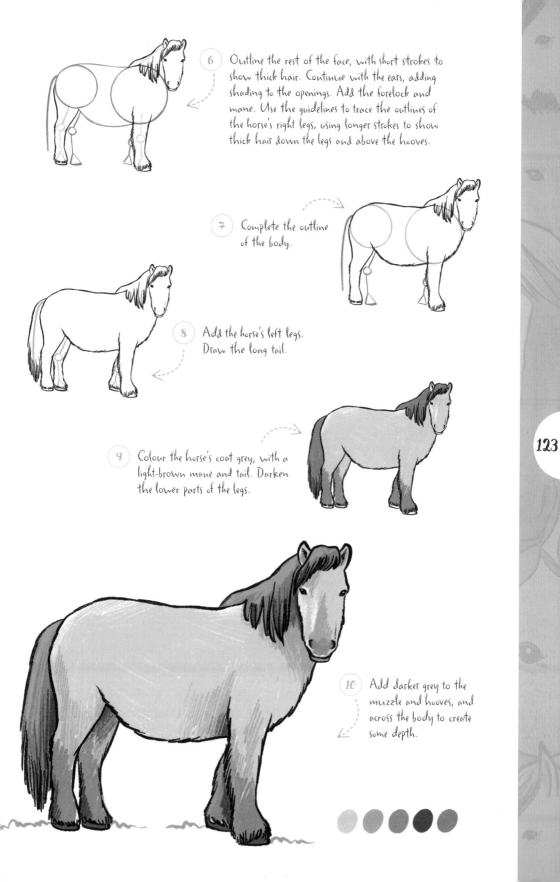

6 Outline the rest of the face, with short strokes to show thick hair. Continue with the ears, adding shading to the openings. Add the forelock and mane. Use the guidelines to trace the outlines of the horse's right legs, using longer strokes to show thick hair down the legs and above the hooves.

7 Complete the outline of the body.

8 Add the horse's left legs. Draw the long tail.

9 Colour the horse's coat grey, with a light-brown mane and tail. Darken the lower parts of the legs.

10 Add darker grey to the muzzle and hooves, and across the body to create some depth.

Przewalski's Horse

Przewalski's horse is a wild horse from the Central Asian steppes.
It is small and muscular, with a short, erect mane.

① Starting with the foal, draw two circles for the body, one slightly bigger than the other. Draw another circle for the head, a quarter the size of the larger circle. On the right side, draw a large circle for the mother's chest, and a smaller circle for the head.

② Connect the circles with curved lines to form the necks and bodies of the mother and foal. Draw an arc on the right of the mother's body as a guide for its back.

③ Add two triangles on the top of each head for ears, and a U-shape beneath for the noses.

④ Add guidelines for the legs, including triangles for the hooves.

⑤ Use the head circle guides to position the eyes. Trace the outlines of the muzzles, including the mouths. Add the nostrils.

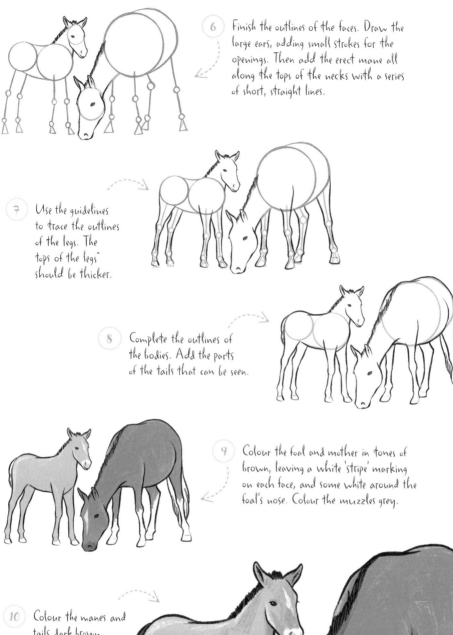

6 Finish the outlines of the faces. Draw the large ears, adding small strokes for the openings. Then add the erect mane all along the tops of the necks with a series of short, straight lines.

7 Use the guidelines to trace the outlines of the legs. The tops of the legs should be thicker.

8 Complete the outlines of the bodies. Add the parts of the tails that can be seen.

9 Colour the foal and mother in tones of brown, leaving a white 'stripe' marking on each face, and some white around the foal's nose. Colour the muzzles grey.

10 Colour the manes and tails dark brown. Darken the legs of the mother, then finish your drawing with some shading.

Brumby

Brumbies are free-ranging, feral horses in Australia, descendants of the first horses that came on ships from England.

1. Draw two circles for the body, one slightly bigger than the other. Draw another circle for the head, a quarter the size of the larger circle.

2. Connect the circles with curved lines to form the neck and the body. Draw a horizontal line through the head circle, and add a U-shape for the nose below.

3. Add guidelines for the horse's right legs, including triangles for the hooves.

4. Draw two triangles on top of the head for the ears. Add guidelines for the other two legs, and a curved tail guide.

5. Position the eye. Trace the outline of the face, including a line for the mouth. Add the nostril, with some shading in the opening.

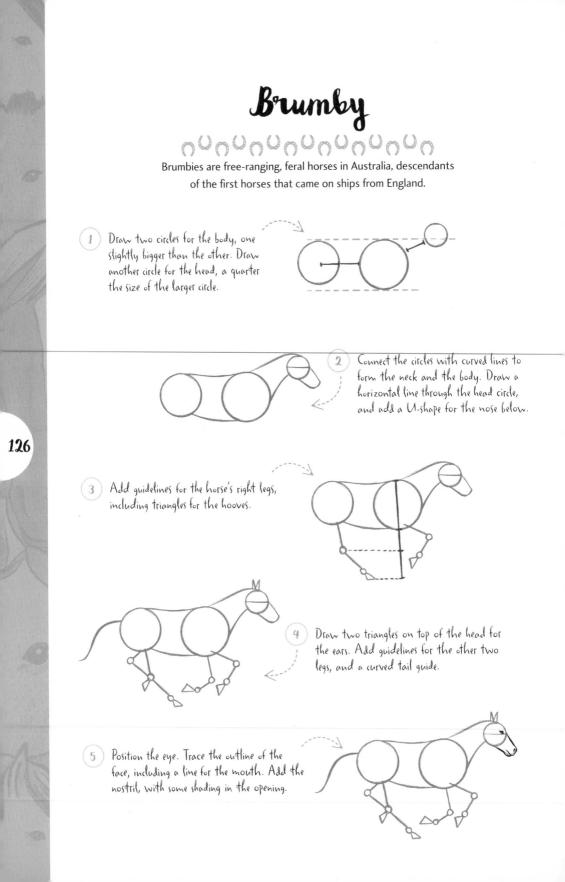

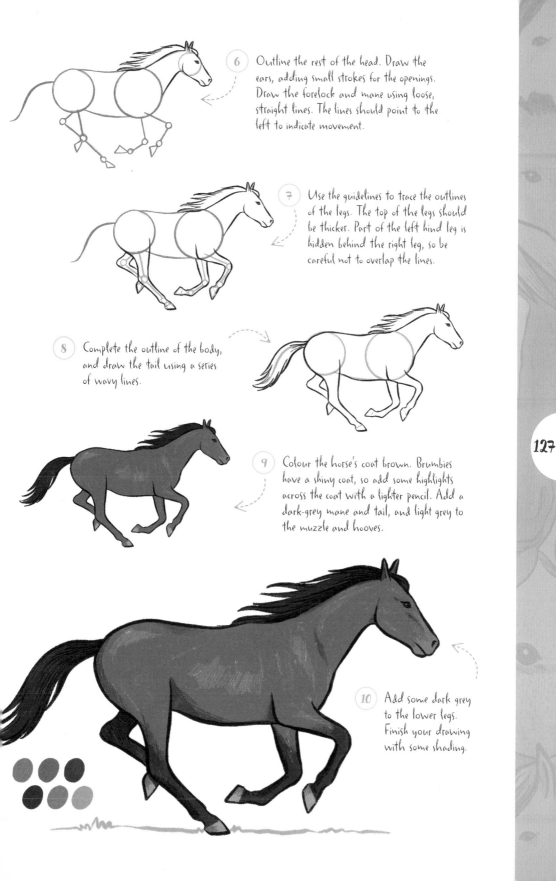

6 Outline the rest of the head. Draw the ears, adding small strokes for the openings. Draw the forelock and mane using loose, straight lines. The lines should point to the left to indicate movement.

7 Use the guidelines to trace the outlines of the legs. The top of the legs should be thicker. Part of the left hind leg is hidden behind the right leg, so be careful not to overlap the lines.

8 Complete the outline of the body, and draw the tail using a series of wavy lines.

9 Colour the horse's coat brown. Brumbies have a shiny coat, so add some highlights across the coat with a lighter pencil. Add a dark-grey mane and tail, and light grey to the muzzle and hooves.

10 Add some dark grey to the lower legs. Finish your drawing with some shading.

About the Artist

Justine Lecouffe is an illustrator, designer and storyboard artist based in London, UK. Her work focuses on digital illustration, graphic design and some dabbling in motion media. Themes of femininity, beauty and nature often dominate her work, making it the perfect fit for clients in the fashion, jewellery and cosmetic sectors. She specializes in design and illustration, but has a long and ambitious wish list of styles and genres to master. When she's not drawing, you can find her cooking comfort food, cycling around London, snapping film photos, or simply scrolling dog and cat memes.

If you'd like to find out more information or see further examples of her work, find Justine on Instagram @justine_lcf.

Acknowledgements

Many thanks to all the readers of *10-Step Drawing: People, 10-Step Drawing: Everyday Things, 10-Step Drawing: Cats* and *10-Step Drawing: Dogs*, who gave me such positive feedback. This was wonderful encouragement and pushed me to draw for this fifth publication.

And I'm again immensely grateful to the team at The Bright Press for another fantastic opportunity and their brilliant support throughout the project.